# ALBRIGHT-KNOX ART GALLERY
# HIGHLIGHTS OF THE COLLECTION

## MARIANN W. SMITH

With a Foreword by Louis Grachos
and
Introductory Text by Douglas Dreishpoon

Scala Publishers
in association with
Albright-Knox Art Gallery

**ALBRIGHT-KNOX ART GALLERY**
**HIGHLIGHTS OF THE COLLECTION**

**Project Directors:** Louis Grachos and Karen Lee Spaulding
**Editors:** Pam Hatley and Pamela Martin
**Designer:** Ann Casady | Casady Design
**Indexer:** Robert Zolnerzak

First published in 2011 by Albright-Knox Art Gallery
in association with Scala Publishers, 10 Northburgh Street, London EC1V 0AT, UK.
www.scalapublishers.com

Printed in China
10 9 8 7 6 5 4 3 2 1

**Albright-Knox Art Gallery**

1285 Elmwood Avenue, Buffalo, New York 14222-1096
www.albrightknox.org

The Albright-Knox Art Gallery's annual operations are supported, in part, by public funds
from the County of Erie and the New York State Council on the Arts, and by the generosity
of our Members.

ISBN: 978-1-85759-661-8
Library of Congress Control Number: 2011934467

## SPONSORS

**THIS PUBLICATION IS SUPPORTED BY A SUBSTANTIAL GRANT FROM THE LENORE D. GODIN GALLERY SHOP FUND.**

Support was also provided by a lead gift from Raymond F. Boehm and Mary Kirsch Boehm and generous donations from Jessica Elaine Smith, Karen and Frederick Spaulding, May W. Webster, and The Robert A. Webster Trust.

The following donors, most of whom are associated with the Albright-Knox Art Gallery Docent Group, also provided important support through their individual gifts.

Anonymous
Eleanor (Dolacinski) Ash
Barbara P. Baird
Janet C. Barnett
Winston R. Barrus, Jr.
Jennifer Bayles
Lucy B. Butsch
Margaret O. Cabana
The Center for the Study of Art
    Architecture, History, and Nature
Mary Theresa Colson
Penelope V. Connors
Dr. John and Mrs. Helen M. Cunat
Ann S. Daughton
Betty W. Eslick
Dennis J. Galucki
Kit Howard
Hallie Howell
Joanne and Karl Kaminski

Marilee A. Keller
Betty Korn
Polly Loonsk
Mr. and Mrs. Sheldon E. Merritt
Sandy and Margie Nobel
Elaine R. Pepe
Merle G. Pranikoff
Lorey Huber Repicci
Elaine Black Richards Ed.D.
Nancy Spector and Genero DeGrazia
Janet G. Stenger
Dorothy Tao
Mary G. Therrien
Connie Walmsley
Ellen and Gene Warner
Milton and Helen Weiser
Dorothy Westhafer
In honor of Roberta and
    Michael Joseph

This Collections-based publication has also been made possible through the generous support provided by The Seymour H. Knox Foundation, Inc.; The John R. Oishei Foundation; and The Margaret L. Wendt Foundation for Albright-Knox Art Gallery Collections-based initiatives.

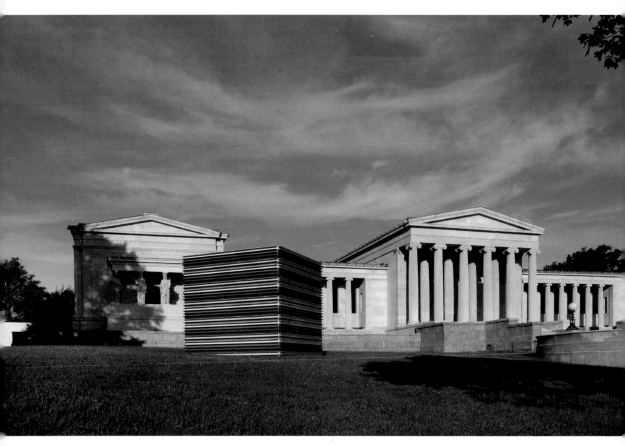

THE ALBRIGHT-KNOX ART GALLERY with *Stacked Revision Structure*, 2005, by Liam Gillick (British, born 1964); powder-coated aluminum, 144 x 144 x 144 inches (365.8 x 365.8 x 365.8 cm); George B. and Jenny R. Mathews Fund, 2005.

# CONTENTS

# FOREWORD

This publication of selected works from the Collection marks the sesquicentennial of The Buffalo Fine Arts Academy, governing body of the Albright-Knox Art Gallery. Critically acclaimed for its outstanding Collection and committed to collecting the art of its time, the Gallery is proud to feature, in these pages, highlights both modern and contemporary. This handbook can be considered a pendant to the scholarly and comprehensive book that accompanies the exhibition *The Long Curve: 150 Years of Visionary Collecting at the Albright-Knox Art Gallery*. There, we celebrate the visual acumen of the great collectors and benefactors who have shaped the Gallery's history: A. Conger Goodyear; Martha Jackson; Seymour H. Knox, Jr.; Natalie and Irving Forman; and Giuseppe Panza di Biumo. This handbook reflects our current acquisition activities and makes note of our cornerstone works, revealing that the contemporary work entering the Gallery's Collection every day complements and enhances our more historical pieces.

INSTALLATION VIEW FROM THE EXHIBITION *Extreme Abstraction*, 2005. In the foreground is *Reckless*, 1998, by Polly Apfelbaum (American, born 1955); synthetic velvet and fabric dye, dimensions variable; Elisabeth H. Gates Fund, 2004. In the background is *Convergence*, 1952, by Jackson Pollock (American, 1912–1956); oil on canvas, 93½ x 155 inches (237.5 x 393.7 cm); Gift of Seymour H. Knox, Jr., 1956.

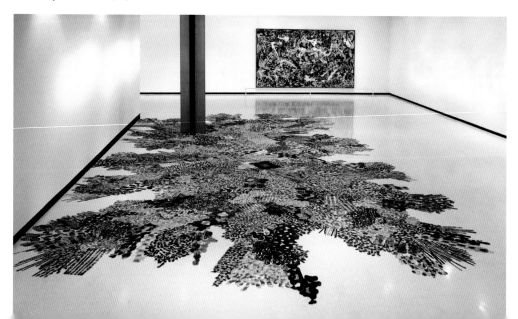

We hope that our efforts continue and honor those of our esteemed predecessors.

This book represents our ambitious and dedicated efforts to acquire artworks for our community and the Buffalo/Niagara region that reflect the exciting innovation in the contemporary art world, both nationally and internationally. We have been intentional about defining our work as broadly as possible, collecting exciting new works in all media: painting, film, video, photography, and installation-scale and large-format indoor and outdoor sculpture. The Gallery has even partnered with national and international museums to acquire works that may previously have been beyond our individual reach. The last decade has seen unprecedented growth in art production, with artists exploring new media, new approaches, and new subjects. It is our intention that this book will illuminate and illustrate the range and diversity of the Gallery's Collection and will reflect what one would encounter on any given visit. Visual conversations are rich in contrasts and similarities, with exciting discoveries at every turn.

The Gallery's far-reaching and comprehensive acquisitions program is made possible with funds derived from an exceedingly strong endowment dedicated solely to the purchase of works of art. This fund was significantly augmented in 2007, when the Gallery and its Board of Directors moved to deaccession numerous objects deemed peripheral to its mission of collecting, exhibiting, and preserving contemporary and modern works of art. Since that time, the Gallery's focus has been on building its Collection for the future, through gifts and purchases that complement its modern masterworks and reflect the innovative and noteworthy artmaking of our time.

Our Curator of Education, Mariann W. Smith, has organized this handbook around themes that are timeless and timely. Mariann is a superb arts educator and a talented writer who is able to distill complex concepts into accessible and cogent interpretations. I am grateful to the Gallery's Chief Curator, Douglas Dreishpoon, for his scholarship, always thoughtful and always respected. The Gallery's Head of Publications,

Pam Hatley, is a model of editorial talent, who brought her consider-
able skill and expertise to this complex project with grace, insight, and
humor. Ann Casady, who has served as the Gallery's designer for nearly
three decades, is to be commended for her Herculean effort in design-
ing this book in record time with just the right sensitivity to both visual
and editorial content. Finally, I would like to acknowledge the continued
outstanding commitment of our Deputy Director, Karen Lee Spaulding.
She founded the Gallery's formal Publications Office in 1977 and is a tire-
less and passionate advocate for the Publications program as an impor-
tant record and documentation of our scholarly efforts. Karen continues
to remind us that maintaining the highest standards in scholarship and
graphic design are important institutional priorities.

This handbook would not have been published without the sig-
nificant and generous financial underwriting from the Lenore D. Godin
Gallery Shop Fund. Lenore was the Gallery's Shop Manager for eighteen
years and was universally esteemed and respected for her creative vision
and devotion to the museum. In her memory, her family established this
fund, which supports projects that are unique and bold in both ambi-
tion and scope. We are grateful to the Fund's trustees, Marjorie Godin
Bryen, Emily Godin Epstein, and Helene Godin, who are responsible
and responsive stewards of this important fund. It is always a pleasure to
work with them as we identify projects worthy of Lenore's memory. I also
extend my gratitude to the Docents of the Albright-Knox Art Gallery,
who not only selflessly give their time and talent as inspired ambassadors
but who also responded with generosity to our request for additional
support for this book. Jennifer Bayles, our Head of Development,
deserves special recognition for her sustained efforts in raising funds
for the publication.

It is our hope that this book will serve as a rich reminder of your visit
to the Gallery and as a gracious invitation to return, again and again.

**LOUIS GRACHOS**

*Director*

# ACKNOWLEDGMENTS

When the Gallery's current Deputy Director, Karen Lee Spaulding, was Head of Publications, she and I spoke frequently about the possibility of a handbook for the Collection. I cannot thank her and Director Louis Grachos enough for selecting me as the author when that publication became a reality. Karen has been my colleague since I first came to Buffalo in 1987—as my supervisor for the past seven years, she has been support, sounding board, and friend, for which I am very grateful. Since he arrived at the Gallery, Louis has shown an unwavering commitment to education, for which he has my entire department's wholehearted thanks. Head of Publications Pam Hatley has been a joy to work with—listening patiently while I talked myself in and out of things, offering excellent advice, showing unflagging enthusiasm all the way through, and, most important, laughing with me and making my words flow seamlessly. Not only did Ann Casady create an outstanding and stunning design, she has been a pleasure to collaborate with all the way through this project. The excellent quality of the images in the handbook results from the dedicated efforts of Media Specialist Tom Loonan, Information Coordinator Kelly Carpenter, and Editorial Assistant Pamela Martin, assisted by Head of Art Preparation Jody Hanson and her staff and Senior Registrar Laura Fleischmann. Sincere thanks also go to Head of Development Jennifer Bayles, who secured funding for this project, and to all those listed on page three who generously contributed to the handbook.

Chief Curator Douglas Dreishpoon, who wrote an introductory text for this publication, is one of the best in his field and a pleasure to have as a colleague. Many thanks also go to Curators Heather Pesanti and Holly E. Hughes, and Curatorial Assistant Ilana Chlebowski, for things they said and research they did that led to ideas and information for the handbook. Thanks are also due to Head of Research Resources Susana Tejada and her staff for their assistance with various aspects of the project.

I also offer my wholehearted thanks to the staff of the Education department—my friends, colleagues, and such outstanding professionals that my frequent absence from the office while preparing the handbook offered me little concern: Associate Curator of Education Nancy Spector, my close friend and colleague of fifteen years; Program Coordinator Sarah Ruszczyk; Group Tour Coordinator Lindsay Kranz; and *Matter at Hand*/ADA Coordinator Cara Nisbeth. I would also like to acknowledge the Gallery's dedicated and talented docent corps, who provide a constant source of inspiration, intellectual stimulation, and friendly laughs.

Finally, I would like to thank my mother, May W. Webster, for her constant love and support, and my daughter Jessica, who makes me extremely happy and proud. I dedicate my work on this handbook to them and also in loving memory of my father, Robert A. Webster, whose scientific mind always remained open enough to be enthusiastic about my interests in the more subjective field of art, and who said, in 2005 when visiting the special exhibition *Extreme Abstraction* one busy Friday evening, "Now this is what a museum should be!"

**– M. W. S.**

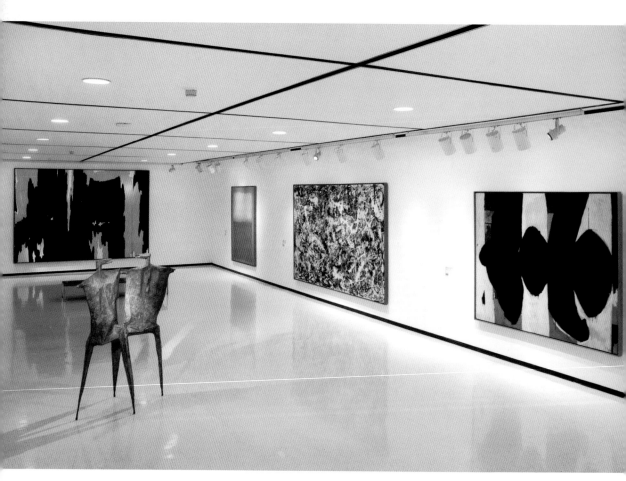

INSTALLATION VIEW OF THE LOWER WEST GALLERY in the 1962 Knox Building, June 2011. From left: *1957-D No. 1*, 1957, by Clyfford Still (American, 1904–1980); oil on canvas, 113 x 159 inches (287 x 403.9 cm); Gift of Seymour H. Knox, Jr., 1959. *Orange and Yellow*, 1956, by Mark Rothko (American, born Russia, 1903–1970); oil on canvas, 91 x 71 inches (231.1 x 180.3 cm); Gift of Seymour H. Knox, Jr., 1956. *Convergence*, 1952, by Jackson Pollock (page 6). *Elegy to the Spanish Republic XXXIV*, 1953–54, by Robert Motherwell (American, 1915–1991); oil on canvas, 80 x 100 inches (203.2 x 254 cm); Gift of Seymour H. Knox, Jr., 1957; Art © Dedalus Foundation, Inc./Licensed by VAGA, New York, NY. In the foreground is *Two Dancing Figures*, 1954, by Lynn Chadwick (British, 1914–2003); iron and composition stone, 71 x 53½ x 24 inches (180.3 x 135.9 x 9.4 cm); Elisabeth H. Gates Fund, 1955.

# ON THE SHOULDERS OF GIANTS

I stand on the shoulders of giants! If that statement sounds hyperbolic, it is meant to be. Having spent more than eleven years immersed in the Albright-Knox's extensive Collection, I am still in awe of what my predecessors—a long line of savvy patrons, directors, and curators—accomplished and the absolute rightness of so many of their choices. Timing is essential for a collecting institution: knowing not only which significant works of art to acquire, but also when and how to acquire them. The Collection at the Albright-Knox was forged by astute decisions, prescient acquisitions, and engaged connoisseurship. One does not hear much about connoisseurship these days, unless one is a wine fanatic or a culinary enthusiast. In the realm of the visual arts, connoisseurship has to do with how one learns to appreciate art, not through reproductions in books, magazines, or even online, but as tangible objects experienced in real space and time. The essence of connoisseurship, as codified at the end of the nineteenth century by the medically trained art critic Giovanni Morelli, was fundamental to the traditional study of art history, as a rigorous methodology that honed one's visual acuity through formal analysis and comparative standards. In academic circles today, when art history intersects with semiotics and critical theory, connoisseurship is often dismissed as anachronistic, along with the notion of a "masterpiece," considered superfluous by some because it entails hierarchical judgments based on quality.

From my admittedly biased perspective, the Albright-Knox's Collection is an empirical model of old-school connoisseurship. Not only are many works the best of their kind, but their sheer excellence reflects a collecting vision driven by qualitative choices. The directors and curators who preceded me, and whose metaphorical shoulders I stand upon, had impeccable taste and discerning eyes. Early on they recognized the importance of collecting the art of their time, and with that realization, they set out to assemble a world-class collection through a series of sustained and focused acquisitions. Buying the right work by the right artist became their mandate: not just any Picasso but the magisterial

Rose Period *La Toilette* from 1906; not just any Gorky but the lushly erotic and painterly *The Liver Is the Cock's Comb* from 1944; and not just any Rauschenberg but the monumental Combine *Ace* from 1962. Intuitive hunches were bolstered by scholarly expertise, an insider's knowledge of the field, and a brave dedication to the new.

The fruits of this philosophy stand out as beacons throughout the Collection. Only one work, for instance, *Dynamism of a Dog on a Leash* by Giacomo Balla from 1912, represents the Italian Futurist, yet this remarkable painting, distinguished by its quirky flourishes and painted frame, consistently appears in every major publication on the subject. Selective acquisitions, however, did not rule out the collecting of an artist in depth. Depending on circumstances, opportunities, and market trends, both approaches were deployed and to this day continue as viable strategies. That said, in instances where only one or two works by an artist grace the Collection, each painting, sculpture, or work on paper represents a quintessential example.

When Director Gordon M. Smith gave Clyfford Still permission to install an exhibition of his own paintings in 1959, Smith was taking a big chance. Offering an artist as mercurial as Still the keys to the museum was, in retrospect, a courageous act of faith that affirmed the Gallery's commitment to contemporary art and artists as the institution's lifeblood. It is one thing for a museum to profess an artist-centric mission, but quite another to embrace that model, which requires continual accommodation and the willingness to do things differently. *Extreme Abstraction*, initiated by Director Louis Grachos in 2005, is a supreme example of what happens when a diverse group of artists, each given a designated space and just a few directives, transforms the institution in completely unexpected ways. More recently, the Argentine painter Guillermo Kuitca and I worked side by side for a whirlwind seven days in February 2010 to install a twenty-eight-year survey of his paintings and works on paper. I learned a great deal from the process, as did each art preparator, registrar, and editor who helped to facilitate the undertaking. In the case of Still, who came to trust Smith and Seymour H. Knox, Jr., as stewards for his abstract art, the result was a generous gift to the Gallery of thirty-one canvases

donated by the artist in 1964. Smith and Knox cultivated an artist-centric ethos through their friendships with many of the painters and sculptors who set the course of American art after 1945. They knew that artistic collaborations keep an institution current, responsive, and agile, and that the institution prospers through these symbiotic relationships.

The Albright-Knox's Collection has inspired generations of curators who began their careers in the landmark gallery spaces designed by E. B. Green and Gordon Bunshaft. Curators are a collection's primary support system; without them, collections can languish, neglected and vulnerable. Curators can be described as the keepers of the goods: vigilant custodians whose main responsibility is to ensure a collection's safety and preservation, and beyond that to make it accessible to the public in creative ways. Curators have been around for as long as art has been collected, and their job description has remained remarkably stable, even in the digital age. By contrast, most works of art are inherently unstable and perpetually changing, even when such changes are invisible to human eyes. Works of art require constant care. Like the human beings who created them, they, too, have rights, for which curators faithfully advocate.

The relationship between the Albright-Knox's Collection and its curators over the course of nearly 150 years has yielded an impressive roster of exhibitions, publications, and programs. The Collection will always be the touchstone to curatorial excellence, inspiring and challenging in equal measure, particularly around the processes of accessioning and deaccessioning. The Gallery's Collection is vital, never static, and continually in flux. Works must be accessioned and deaccessioned with deliberate thoughtfulness to keep the institution true to its collecting mission. Every acquisition enhances the possibilities for curatorial interaction, and with a collection as expansive as the Albright-Knox's, the options are truly manifold. To have unlimited access to such a stellar collection is a privilege: a gift passed down by the many colleagues whose wise and well-timed judgments made it possible.

**DOUGLAS DREISHPOON**
*Chief Curator*

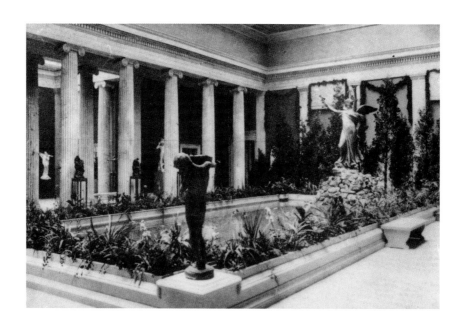

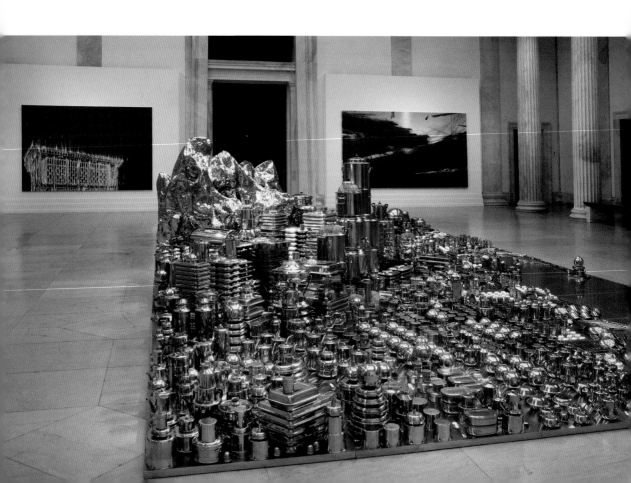

# INTRODUCTION

When Louis Grachos left the New Mexico contemporary arts center SITE Santa Fe in 2003 to become director of the Albright-Knox Art Gallery, he brought with him his great passion for the art and artists of today. Grachos rededicated the Gallery to the collection and display of contemporary art and promoted an approach to exhibitions and programming that centers on living artists.

One of the highlights of Grachos's tenure thus far has been the special exhibition *Extreme Abstraction*, presented in summer 2005, which attracted dozens of artists from all over the world to its weekend-long opening celebration. Avant-garde art from throughout the twentieth century was placed side by side with the art world's newest creations, filling all three of the Gallery's buildings and allowing for striking combinations like Jackson Pollock's painting *Convergence*, 1952, and Polly Apfelbaum's fabric piece *Reckless*, 1998 (page 6).

This handbook derives, in part, from that groundbreaking exhibition, which sparked the concept for a series of ongoing Collection-based shows called *REMIX* that present modern and contemporary art in thought-provoking and ever-changing thematic contexts. With this book, we hope to provide readers with an experience similar to an actual museum visit and also to confirm the Albright-Knox Art Gallery's continuing focus on the art of its time. The works of art featured represent only a small percentage of the more than 6,500 pieces that comprise the Gallery's Collection; although they have been divided into general themes and spotlight groupings, many would fit easily into more than one category. As we publish this handbook, the Albright-Knox Art Gallery's Collection continues to grow under the direction and leadership of Grachos, who exemplifies the forward-thinking tradition of a series of directors who knew and embraced the risks of collecting contemporary art.

**ABOVE:** INSTALLATION VIEW of the Albright Art Gallery's Sculpture Court during *An Exhibition of Contemporary American Sculpture*, 1916.

**BELOW:** INSTALLATION VIEW of the Albright-Knox Art Gallery's Sculpture Court during the exhibition *Surveyor*, 2011. In the center is Zhan Wang's *Urban Landscape Buffalo*, 2005–10 (page 45). In the background, from left, are Gary Simmons's *D.C. Pavillion*, 2007 (page 143), and Barnaby Furnas's *Flood*, 2007 (page 38).

# A CONTEMPORARY HISTORY

MARIANN W. SMITH

**ALBERT BIERSTADT**
(American, born Germany,
1830–1902). *The Marina
Piccola, Capri,* 1859. Oil
on canvas, 42 x 72 inches
(106.7 x 182.9 cm). Gift of
the artist, 1863.

When The Buffalo Fine Arts Academy rented its first official office, storage, and exhibition space in 1862, the painter Lars Sellstedt (see page 44) announced, "Thus, amid the surging billows of civil war arose this haven of peace."[1] Sellstedt was one of the original founders of the Academy, which is one of the oldest public arts organizations in the United States. Many of the founders' names, such as William P. Letchworth and Sherman S. Jewett, are well-known in the Buffalo/Niagara region; others, like former United States president Millard Fillmore, are recognized nationwide. From 1862 to 1905, while funding was sought to erect a new museum building, The Buffalo Fine Arts Academy rented four different locations in the city of Buffalo.

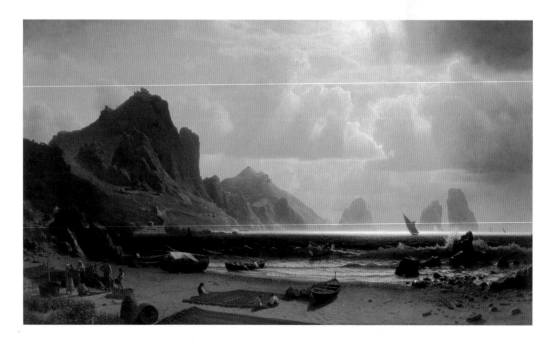

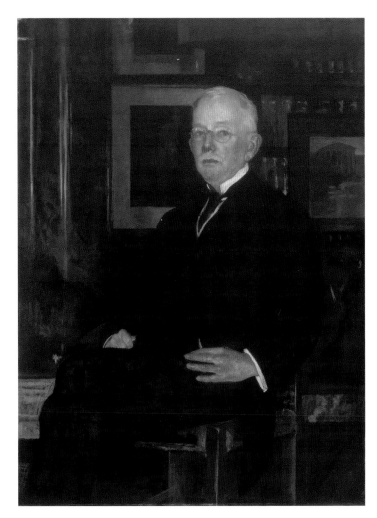

**EDMUND CHARLES TARBELL**
(American, 1862–1938).
*Portrait of John Joseph Albright*,
1914. Oil on canvas, 50 x 37
inches (127 x 94 cm). Gift of
Edmund Hayes, 1915.

The Academy's first exhibition took place less than two months after its incorporation, with the popular work *The Marina Piccola, Capri,* 1859 (opposite), as centerpiece. Painted by the American artist Albert Bierstadt, the scene of fishing activities on an island off the coast of Italy under a dramatic sky is still a favorite among current audiences. In 1863, the year following the inaugural exhibition, Bierstadt donated the painting to the Academy—its first of many gifts from an artist. The accompanying note to Academy president Henry W. Rogers reads, "May I ask you to accept whatever is good in it as a sincere expression of my best wishes for the true and abundant success of the Academy, and as a small payment on account of a large debt which every artist owes to his profession."[2] Since that time, it has been an Academy priority to collect contemporary art; while accepting a painting from Bierstadt was hardly controversial, many subsequent acquisitions would prove to be more of a challenge and a risk.

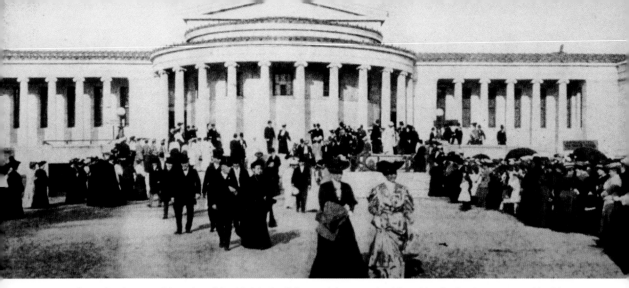

Guests leaving a special preview of the Albright Art Gallery and the general public waiting for the doors to open, May 31, 1905. From *The Buffalo Illustrated Times*, June 4, 1905.

At a memorable meeting of the Academy's board of directors in January 1900, the philanthropist John J. Albright (see page 17) began the new millennium by offering funds for the construction of a permanent home for the growing Collection. The well-known architect Edward B. Green, who had moved to Buffalo in 1881, was commissioned to design the structure in the neoclassical style. The museum was originally intended to serve first as the Arts Pavilion at the Pan-American Exposition of 1901; however, delays at the marble quarries postponed its completion until 1905, when the Albright Art Gallery was dedicated on May 31.

Charles M. Kurtz, the Gallery's first director, began the institution's dedication to the art of its time. His commitment to local artists resulted in the earliest manifestations of today's *Beyond/In Western New York* exhibitions, which involve more than a dozen area arts organizations. Kurtz also planned to mount the first major museum exhibition of pictorial photography, but died suddenly in 1909 before it could be carried out.

Kurtz's plan was completed by his successor, Cornelia Bentley Sage Quinton, the first woman to be named director of a major American museum. Although today photography exhibitions are presented frequently, in the early twentieth century the medium was not yet considered art by most people. With no precedent for such an undertaking, Quinton put the show in the hands of a specialist—Alfred Stieglitz (American, 1864–1946), who exhibited avant-garde photography in his New York gallery. The Albright was taking an incredible risk, and Stieglitz, too, understood the exhibition's importance, writing to his colleagues that the reputation of photography was at stake. Worries were unfounded, and the 1910 *International Exhibition of Pictorial Photography* (opposite) turned out to be a landmark in the history of the medium in the United States. Today, the Gallery has an extensive collection of photography, which continues to grow.

Another of Quinton's significant achievements—and one that attracted international atten-

tion—was a 1916 exhibition featuring eight hundred works by 168 contemporary American sculptors. She also organized exhibitions and acquired work by American painters such as Robert Henri (1865–1929) and George Bellows (1882–1925), whose styles were not yet widely accepted by the public. Henri's *Tam Gan*, 1914, was purchased directly from the artist the year after it was created; Bellows's painting *Elinor, Jean, and Anna*, 1920, was acquired from his dealer in 1923.

When Quinton left Buffalo in 1924 to become director of the California Palace of the Legion of Honor in San Francisco, William M. Hekking took over. In addition to his focus on public education, he continued to collect important works of the time. Acquisitions during Hekking's tenure were successful in great part due to the efforts of Academy board member A. Conger Goodyear, who, in 1926, organized a group called Fellows for Life. Members of this group contributed $1,000 or more each year to support Gallery acquisitions, one of which is Pablo Picasso's important work *La Toilette* of 1906.

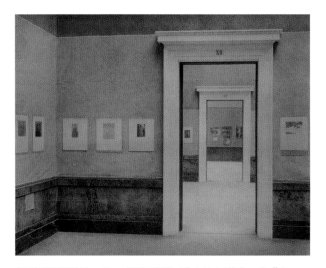

**KARL STRUSS** (American, 1886–1981). Albright Art Gallery, Buffalo, New York, gallery interior showing the *International Exhibition of Pictorial Photography*, 1910. Platinum print, 37⁹⁄₁₆ x 4⁹⁄₁₆ inches.

Gordon Washburn continued both Hekking's focus on education and the Gallery's practice of placing itself on the cutting edge of the art world. To that end, in 1939, he and the board of directors established the Room of Contemporary Art Fund, the major portion of which—$100,000—was contributed by Academy president Seymour H. Knox, Jr., and his family. Artwork purchased with this fund was exhibited in a designated room at the museum, where many highlights of the Gallery's Collection began their lives in Buffalo. These works include Henry Moore's *Reclining Figure*, 1935–36 (page 78), the first work by the important British sculptor to be purchased by a North American museum.

When Washburn left in 1942 to become head of the Rhode Island School of Design's Museum of Art, Andrew C. Ritchie took over as director, leading the Gallery through the difficult years of World War II. In June 1945, he took a yearlong leave of absence to serve as Technical Advisor and Representative of the Commanding General in the United States Forces in Austria, helping to recover art that had been looted by the Nazis in that area. One of his successes was the recovery of Paul Gauguin's *The Yellow Christ*, 1889 (page 20), which had been stolen by the Nazis from the collector and dealer Paul Rosenberg in Paris. In gratitude, Rosenberg sold the painting to the Gallery at a favorable price in July 1946.

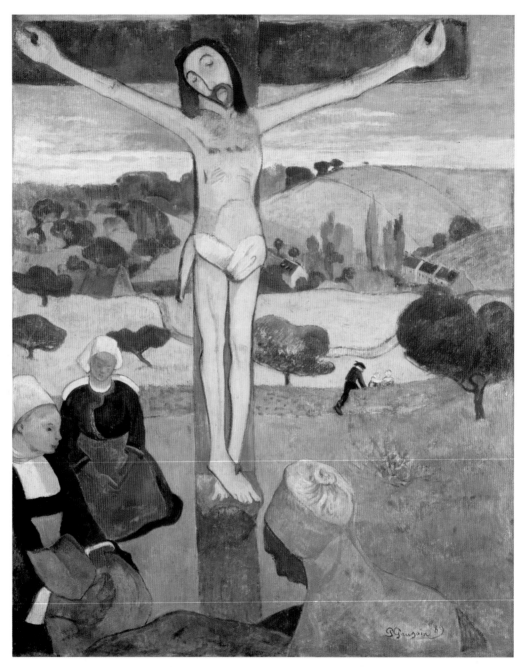

**PAUL GAUGUIN** (French, 1848–1903). *The Yellow Christ*, 1889. Oil on canvas, 36¼ x 28⅞ inches (92.1 x 73.3 cm). General Purchase Funds, 1946.

*The Yellow Christ* is a key painting from Paul Gauguin's visits to the French province of Brittany and reflects the artist's close affinity with the landscape, the people, and their way of life. For the Bretons, the seasonal agricultural cycle was intimately tied to the cycle of life and also to religion. Here, Gauguin represents fall—the time of harvest—and its association with death, which will lead to resurrection in the spring.

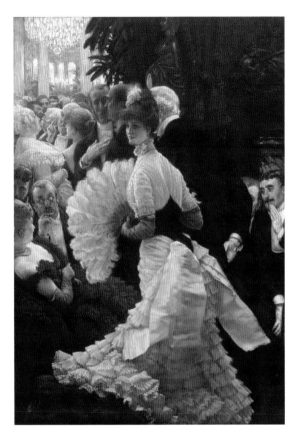

**JAMES TISSOT**
(French, 1836–1902). *L'Ambitieuse (Political Woman)*,
1883–85. Oil on canvas, 56 x 40 inches
(142.2 x 101.6 cm). Gift of William M. Chase, 1909.

This painting, in which the sight of a beautiful young
woman on the arm of a much older gentleman has
drawn the attention of many of the other men at the
gathering, is a favorite of Gallery visitors today as
they admire Tissot's skill at representing detail and
contemplate who is using whom.

Ritchie resigned in 1949 to become director of painting and sculpture at The Museum of Modern Art in New York. He was succeeded by Edgar Schenck, who, while struggling with finances to repair the aging museum building, nonetheless continued the Gallery's commitment to contemporary art, often to the criticism of the public and the media. At a 1955 exhibition held in celebration of the fiftieth anniversary of the dedication of the 1905 Albright Building, works like James Tissot's *L'Ambitieuse (Political Woman)*, 1883–85 (above), were admired, while more contemporary acquisitions drew primarily negative comments. Schenck lamented a situation museums often still face today: "accused of being too highbrow on the one hand and of dallying too much with popular appeal on the other."[3]

When Schenck resigned in 1955 to become director of the Brooklyn Museum, a legendary partnership began between the Gallery's next director, Gordon M. Smith, and Seymour H. Knox, Jr. (see pages 22 and 23), president of the board of directors since 1938. This partnership resulted in the acquisition of many of the Gallery's best-known works and a brand-new building. Smith and Knox took numerous risks, often buying a work only months after its creation, sometimes before the paint was fully dry. To expedite the process, Knox would often purchase works personally and subsequently donate them to the museum.

Collecting contemporary art is always a risk, but Smith and Knox were overwhelmingly successful, especially in the case of works by the artists now known as the Abstract Expressionists (see page 10). Facing the aftermath of World War II and the beginning of the Cold War, most Americans preferred art that was reassuring and comfortable. But artists like Willem de Kooning, Jackson Pollock, and Mark Rothko, who felt that traditional forms of art could no longer adequately express the mood of their time and place, developed new, extremely personal styles that challenged public taste. Today their work is seen as a milestone in the history of twentieth-century art and one of the reasons the center of the art world shifted from Paris to New York.

Clyfford Still was the most eccentric and elusive of the Abstract Expressionists, avoiding all who tried to interpret or commercialize his work and making it next to impossible for anyone to acquire his paintings. In 1957, through a combination of Smith's diplomacy and persistence, and Knox's financial support, the Gallery managed to acquire one painting by Still. In 1959, another purchase was permitted and, with the artist's approval and assistance, a solo exhibition was held at the museum (opposite). Still was so pleased with his experience in Buffalo that in 1964 he presented the Gallery with thirty-one additional paintings. In 1996, his widow bequeathed to the Gallery approximately 1,300 photographs and more than 2,600 slides from her husband's personal collection.

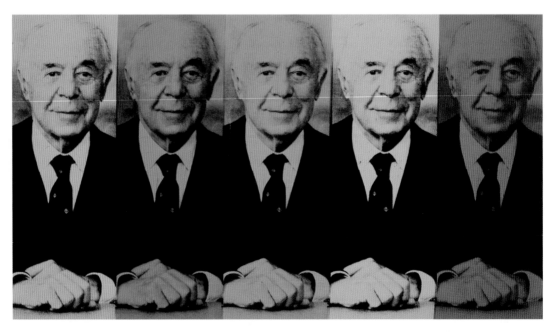

**ANDY WARHOL** (American, 1928–1987). *Portrait of Seymour H. Knox*, 1985. Acrylic on canvas, 40 x 70 inches (101.6 x 177.8 cm). Gift of Mr. and Mrs. Seymour H. Knox III and Mr. and Mrs. Northrup R. Knox in honor of Seymour H. Knox for his 60-year contribution as a member of The Buffalo Fine Arts Academy, 1985.

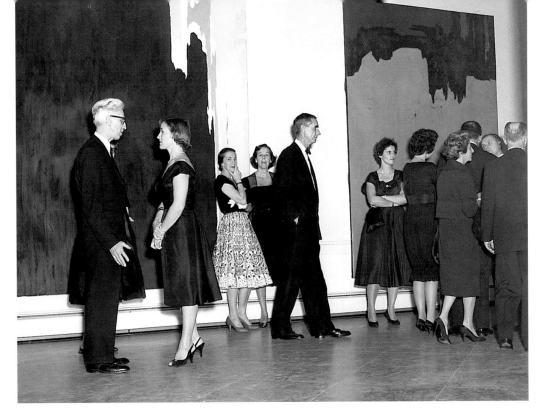

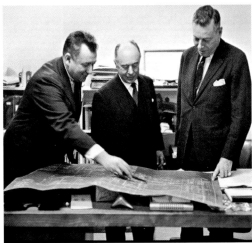

**TOP:** Clyfford Still, at left, talking with guests at the Members' opening for the exhibition *Paintings by Clyfford Still*, November 4, 1959.

**BOTTOM:** Gordon Bunshaft, Seymour H. Knox, Jr., and Gordon M. Smith study a blueprint of a floorplan for the new addition, December 14, 1961.

Another historic collaboration between Smith and Knox resulted in the 1962 addition to the Gallery, designed by Buffalo native Gordon Bunshaft of the New York architectural firm of Skidmore, Owings and Merrill (at left). The new wing opened to the public on January 21, 1962, almost exactly one hundred years after the founding of The Buffalo Fine Arts Academy. Between opening day and April 1, 1962, nearly 250,000 people visited the newly renamed Albright-Knox Art Gallery.

The 1962 Knox Building is designed in modern style, with rectilinear, functional forms, and Bunshaft made every effort to integrate it with the neoclassical 1905 Albright Building. For example, he deftly designed the Sculpture Garden as an intermediary space, allowing the columns of the Albright Building to be reflected in the vertical glass auditorium panels of the Knox Building (page 24).

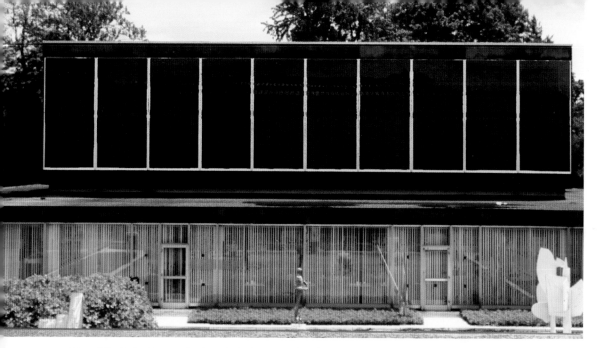

View of the Auditorium exterior, from the Sculpture Garden of the 1962 Knox Building.

When Smith retired in 1973, he was followed as director by Robert T. Buck, Jr. Exhibitions of contemporary art continued, often featuring the work of living artists who visited the Gallery and participated in installations and openings. Robert Rauschenberg's solo exhibition of 1977 featured many of the artist's famous Combines, including *Ace*, 1962 (page 29), which had been presented by Seymour H. Knox, Jr., to the Gallery only one year after its creation.

In 1983, when Buck became the second Gallery director to move to the Brooklyn Museum, Douglas G. Schultz began his nearly twenty-year tenure as director, during which many new works of modern and contemporary art were added to the Collection, and numerous important exhibitions took place, including *Abstract Expressionism: The Critical Developments* (1987), *Jenny Holzer: The Venice Installation* (1991), and *Clyfford Still* (1993). In summer 1990, Holzer became the first woman to represent the United States at the prestigious Venice Biennale exhibition (opposite), with a submission developed by the Gallery's chief curator, Michael Auping. After winning the Golden Lion award for best national participation, the exhibition traveled to Buffalo in 1991 as part of an international tour. At this time, the Gallery commissioned four benches for the Sculpture Court, each of which is carved with examples from one of Holzer's four major text series.

It was also during Schultz's directorship that a third structure became part of the Gallery—Clifton Hall, originally built in 1928 to house the Buffalo Museum of Science. When plans began for the current Science Museum on Humboldt Parkway, the Elmwood Avenue building was sold to The Buffalo Fine Arts Academy. In 1929, Colonel Charles Clifton donated funds for its renovation into art school classroom space. From 1954 to 1987, it was part of the University at Buffalo and Buffalo State College. In 1987, it once again became part of the Albright-Knox. A renovated Clifton Hall, with offices and exhibition space, reopened in May 1992.

When Schultz retired in 2002, a national search led to the Gallery's current director, Louis Grachos. One of his innovations in acquisitions—in response to the fact that contemporary art can often be financially out of reach of a single institution—has been to coordinate joint purchases with other museums. To date, the Gallery has shared three important acquisitions: Bruce Nauman's video-based work *Green Horses*, 1988 (page 74), with the Whitney Museum of American Art, New York; Rachel Whiteread's large sculpture *Untitled (Domestic)*, 2002 (page 57), with the Carnegie Museum of Art, Pittsburgh; and Felix Gonzalez-Torres's important stack piece *Untitled (Double Portrait)*, 1991 (below right), with the Tate Gallery, London.

Several contemporary acquisitions have enhanced the ongoing relationship between the 1905 Albright Building and the 1962 Knox Building. On the lawn overlooking Delaware Park's Hoyt Lake, Liam Gillick's *Stacked Revision Structure*, 2005 (page 4), creates intense visual interest by simultaneously enhancing and providing a contrast to the exteriors of both structures.

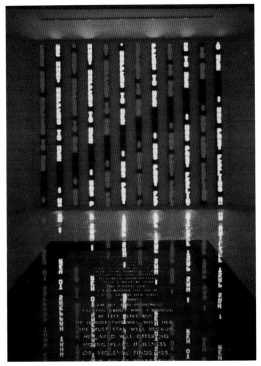

**JENNY HOLZER** (American, born 1950). Installation view of The Child Room (Gallery A) from *Jenny Holzer: The Venice Installation*, United States Pavilion, The 44th Venice Biennale, May 27–September 30, 1990.

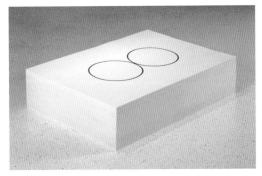

**FELIX GONZALEZ-TORRES** (American, born Cuba, 1957–1996). *Untitled (Double Portrait)*, 1991. Offset print on paper (endless supply), 39⅜ x 27½ inches (100 x 69.9 cm) each sheet. Purchased jointly by Albright-Knox Art Gallery, Buffalo with funds from Charles Clifton, James S. Ely, Charles W. Goodyear, Sarah Norton Goodyear, Dr. and Mrs. Clayton Peimer, George Bellows and Irene Pirson Macdonald Funds; by exchange: Gift of Seymour H. Knox, Jr. and the Stevenson Family, Fellows for Life Fund, Gift of Mrs. George A. Forman, Gift of Mrs. Georgia M. G. Forman, Elisabeth H. Gates Fund, Charles W. Goodyear and Mrs. Georgia M. G. Forman Fund, Edmund Hayes Fund, Sherman S. Jewett Fund, George B. and Jenny R. Mathews Fund, Bequest of Arthur B. Michael, Gift of Mrs. Seymour H. Knox, Sr., Gift of Baroness Alphonse de Rothschild, Philip J. Wickser Fund and Gift of the Winfield Foundation; and Tate, London, with assistance from the American Fund for the Tate Gallery and the Latin American Acquisitions Committee, 2010.

The simple forms of Gonzalez-Torres's works often belie their complex layers of meaning. *Untitled (Double Portrait)* relates to one of his most significant themes—two individuals united in friendship, support, and love.

Jim Hodges's *look and see*, 2005 (below), originally designed to mediate between the city, trees, and water surrounding Battery Park in New York, serves a similar purpose in the Gallery's Sculpture Garden. Its dynamic S-curve incorporates openings that allow visitors to see from one side to the other, and its numerous mirrored surfaces reflect both buildings as well as the natural environment.

Overlooking the Sculpture Garden is Leo Villareal's commissioned work *Light Matrix*, 2005 (at right), comprising 360 clusters of extremely

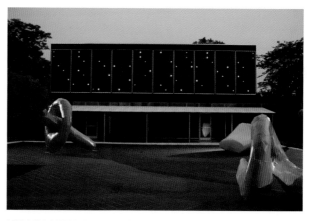

**LEO VILLAREAL** (American, born 1967). *Light Matrix*, 2005. LEDs, microcontroller, and mounting hardware, dimensions variable. Gift of Mr. and Mrs. Peter B. Flickinger, 2005.

bright white LEDs (light emitting diodes) that dance in neverending patterns controlled by a computer program. In his design, Villareal took into careful consideration the work's location, explaining, "The idea was to have a very light touch with the building—to do something that didn't intrude upon the architecture, which I find incredibly beautiful. I like the way that you can see the neoclassical building reflected in the modern building, and then there's the additional layer of this ephemeral, sequenced light. It's almost like three generations of different systems at work."[4]

**JIM HODGES** (American, born 1957). *look and see*, 2005. Enamel on stainless steel, 138 x 300 x 144 inches (350.5 x 762 x 365.8 cm). Sarah Norton Goodyear, George B. and Jenny R. Mathews, and Charles Clifton Funds, 2006.

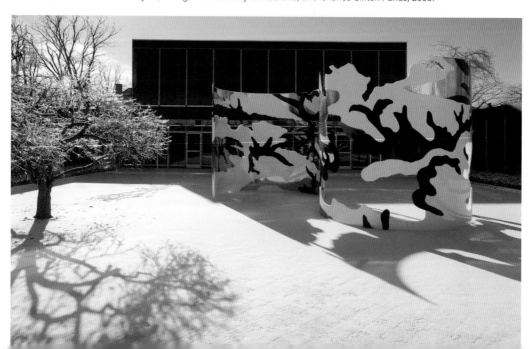

# CONTINUITY IN CHANGE

From its beginnings, the history of art has been a story of change; but never have the changes been as dramatic as those of the past 150 years. Artists have pushed every limit of their profession in response to overwhelming transformation: industrialization; inventions like the automobile, radio, and television; air and space travel; computers and other advanced technology; two world wars and constant struggles over land, resources, and religion intensified by new, more destructive weapons; threats to the environment; feminism; the Civil Rights movement; advances in science and medicine; and globalization of the economy, commerce, and the media. Contemporary artists, especially, expect viewers to be much more than just passive observers and hope we will meet them halfway, bringing our own lives and experiences to our interactions with their work.

Regardless of century, geographic location, medium, or style, many artists tend to return to certain basic themes. Who we are, where we live, what we believe, and how we interact with each other and our environment have been of concern to artists since canvases were cave walls. The works featured in this handbook, which date from 1782 to 2011, illustrate the impressive and creative diversity with which artists have considered these eternal themes.

Contemporary artists continue to devise new ways to transform what might be called "recycled" materials. Tom Sachs takes objects from everyday life and turns them into what he calls *bricolage*, which he defines as "the French term for do-it-yourself repair." He has stated, "Bricolage comes from a culture that repairs rather than replaces—American culture just replaces."[1] In *Trojan*, the artist gives new life to cinder blocks, wood wedges, a wheeled dolly, and a collection of Trojan-brand car batteries from an old police car he drives, all cast in

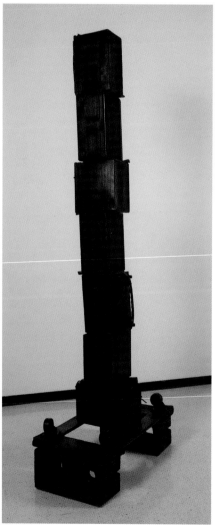

1

2

bronze. Rachel Harrison also uses found objects and has commented that her sculpture is about "the need to see things from many angles, many points of view." For her, the title is also "an object. It is another place where I can add a 'thing.'"[2] The title *Vampire Wannabes* was borrowed from the American poet Rae Armantrout's "Wannabe," published in *Versed* in 2009. Robert Rauschenberg often incorporated items he found on the streets of New York into his art, calling works like *Ace* "Combines" because they combined painting and sculpture, life and art, and the artist and his creations.

3

**1**
**TOM SACHS**
(American, born 1966). *Trojan*, 2008. Cast silicon bronze and photo-etching with ammonium sulfide, edition 3/5, 88 x 30 x 18 inches (223.5 x 76.2 x 45.7 cm). Gift of Mrs. George A. Forman, by exchange, 2008.

**2**
**RACHEL HARRISON**
(American, born 1966). *Vampire Wannabes*, 2010. Wood, polystyrene, cement, acrylic, safety vest, and Airport Extreme, 99 x 35 x 32 inches (251.5 x 88.9 x 81.3 cm). Sarah Norton Goodyear Fund and Bequest of Arthur B. Michael, by exchange, 2011.

**3**
**ROBERT RAUSCHENBERG**
(American, 1925–2008). *Ace*, 1962. Oil, cardboard, wood, and metal on canvas, 108 x 240 inches (274.3 x 609.6 cm). Gift of Seymour H. Knox, Jr., 1963. Art © Estate of Robert Rauschenberg/Licensed by VAGA, New York, NY.

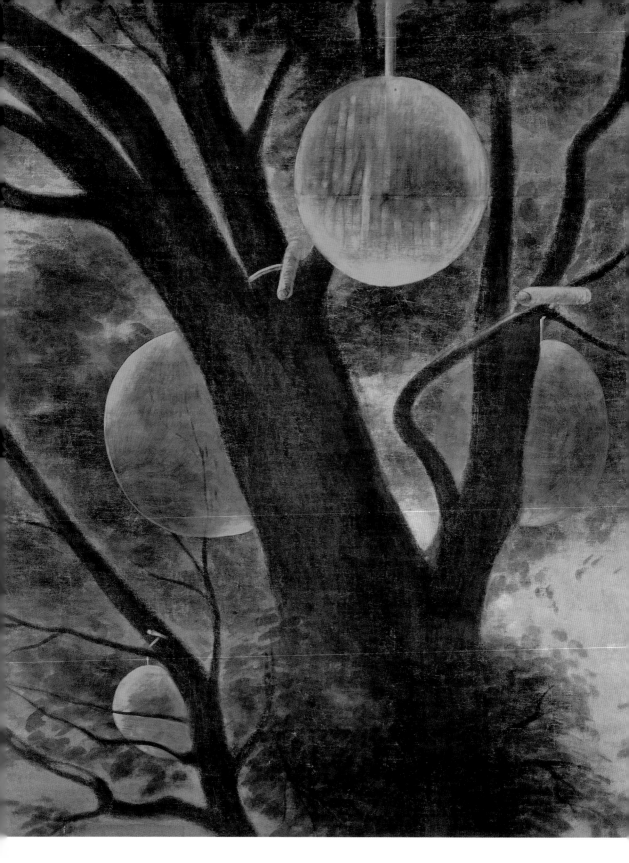

The world around us has provided artists with seemingly limitless possibilities for expression. In past centuries, the primary goal of many artists was to represent a scene as precisely as possible in an attempt to create the effect of a window looking out on the world. Other artists used elements of landscape to emphasize the story they were trying to tell—darkness can represent a sense of foreboding, for example, and a sunrise can be a symbol of hope for a new beginning. In the nineteenth century, American landscape, seen as God's creation, was often given spiritual properties, with the power to transform humanity. Since then, many artists have altered the landscape to achieve expressive goals, while others manage to evoke the natural world without using any identifiable elements.

**FRANCESCO CLEMENTE** (Italian, born 1952). *Son*, 1984. Oil on linen, 112 x 91 inches (284.5 x 231.1 cm). George B. and Jenny R. Mathews Fund, 1985.

Upon reading the title and seeing the yellow orbs in this enigmatic painting by Francesco Clemente, we tend to think of the celestial sun. But the spelling, S-O-N, alludes to a different meaning. Clemente's affinity with nature and his frequent self-portraits, along with his statement "The body is a mirror of the environment,"[1] might suggest an interpretation of the tree as a kind of self-portrait. Or perhaps the artist could be considered the offspring of the tree—the "son" in the title. Clemente, who is knowledgeable about a diversity of spiritual beliefs, incorporates other references as well. Many cultures share the concept of a "tree of life," which underscores the interrelation of all living things. Often trees are viewed as playing a spiritual role by linking the earth (the material) and the sky (the spiritual) with their roots and branches. In India, where Clemente spends much of his time, a triple tree holding three suns symbolizes the Hindu trinity of Brahma, Vishnu, and Shiva, who create, maintain, and destroy the world again and again in a never-ending cycle of life, death, and rebirth.

Anselm Kiefer was born the year World War II ended, when both the landscape and the psyche of Germany had been devastated. Growing up in that atmosphere, he set out to study why human beings behave the way they do, feeling that art—by helping to answer these types of questions—could perhaps make the world a better place. After creating numerous works that were often very dark, Kiefer began including small elements of hope, such as pieces of real straw embedded in his thick surfaces. In this work, a white opening in the earth appears to spread golden light across a burned field. Near the center is a three-dimensional lead funnel, which in Kiefer's work generally represents a speaker to God—any God. The funnel also refers to the medieval practice of alchemy, the endeavor to change base metals, like lead, into gold. Alchemy has a philosophical side as well, representing concepts like the transformation of matter to spirit or, more generally, a thing of little value into something priceless. In Kiefer's work, from the devastation of war emerges hope for the future.

**ANSELM KIEFER**
(German, born 1945). *die Milchstrasse (Milky Way)*, 1985–87. Emulsion paint, oil, acrylic, and shellac on canvas with applied wires and lead, 150 x 222 inches (381 x 563.9 cm). In Celebration of the 125th Anniversary of The Buffalo Fine Arts Academy, General and Restricted Purchase Funds, 1988.

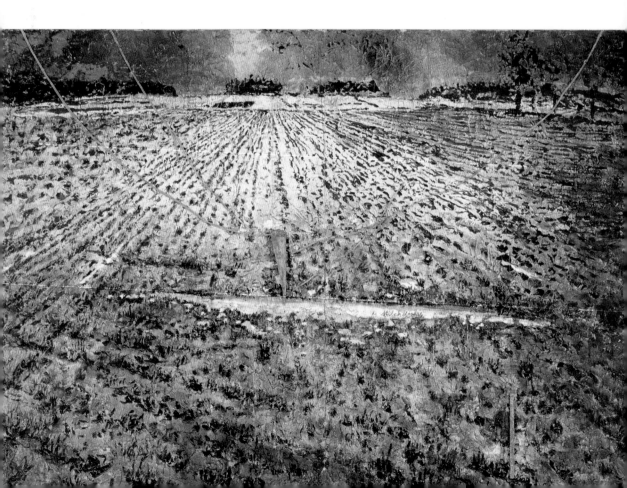

An approaching storm was one of George Inness's favorite themes, and he painted it almost two dozen times. Inness believed that the relationship between man and nature was one of equals living in a physical and spiritual harmony dominated by neither. *The Coming Storm* reflects this philosophy in a number of ways: there is a balance between cultivated and untamed nature; the approach of what appears to be a dramatic storm does not seem to concern the farmer, who continues to plow his field, knowing the rain will help his crops to grow; the houses are nestled safely and snugly in the trees; and the smoke from their chimneys rises up to join the clouds. Inness has also included a dead stump next to the young tree in the lower right, a common nineteenth-century symbol of the cycle of life.

**GEORGE INNESS**
(American, 1825–1894).
*The Coming Storm*, 1878.
Oil on canvas, 26 x 39
inches (66 x 99.1 cm).
Albert H. Tracy Fund, 1900.

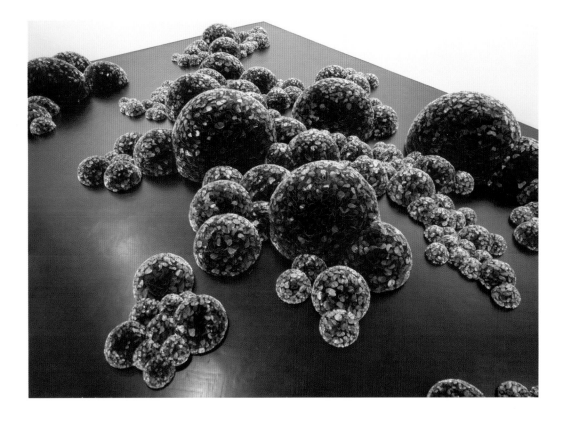

Tara Donovan creates works of art from huge collections of everyday objects such as fishing line, plastic straws, buttons, toothpicks, and Mylar, deciding how to use each material based on its inherent qualities. Donovan's material of choice for the Gallery's work was the polyester film referred to in the title, which is dark on one side and reflective on the other. She found that by rolling precut pieces of Mylar into cone shapes, she could take advantage of its ability to both reflect and absorb light. The sculpture's placement on the floor allows us to walk around and be-tween the sections to experience the diversity of effects created by the interactions of light and shadow. Many viewers see parallels in this work to the natural world, from the microscopic to the macroscopic: spores and bacteria; flora and fauna, such as mushrooms and coral; the night sky and the universe. Donovan explains, "My work might appear 'organic' or 'alive' specifically because my process mimics, in the most elementary sense, basic systems of growth found in nature."[2]

**TARA DONOVAN**
(American, born 1969).
*Untitled (Mylar)*, 2007.
Mylar and glue,
30 x 248 x 203 inches
(76.2 x 629.9 x 515.6 cm).
Gift of Mrs. Georgia M. G. Forman, by exchange, 2008.

The swirling waves, rain, and wind in Sandra Cinto's *Tempest in Red* remind us of the often overwhelming forces of nature and our frequent inability to control their power. Cinto's pairing of materials—red acrylic paint and silver permanent marker—create a beautiful, yet eerie effect. The forms of the waves and the atmosphere of the scene are reminiscent of centuries-old Eastern and Western storm paintings, which often contain ships struggling against the elements. The work also refers to contemporary worldwide immigration issues and those who journey across potentially dangerous waters in search of better lives. On a more general level, *Tempest in Red* can be seen as hopeful—an allusion to the difficulties we face and the new beginning that may present itself after the storm.

**SANDRA CINTO**
(Brazilian, born 1968).
*Tempest in Red*, 2009.
Acrylic and permanent pen
on canvas, 63 x 98 inches
(160 x 248.9 cm). Pending
Acquisition Funds, 2011.

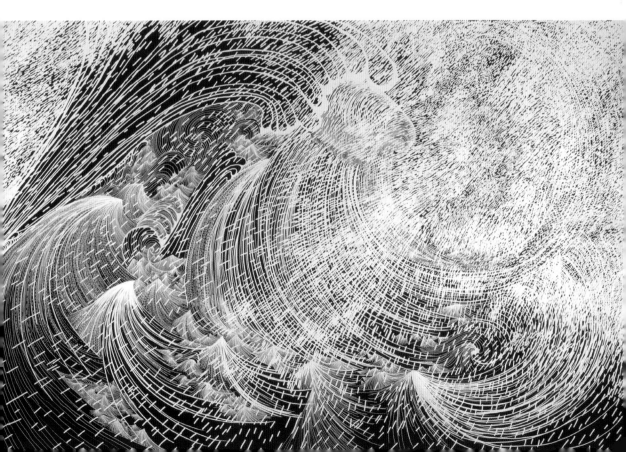

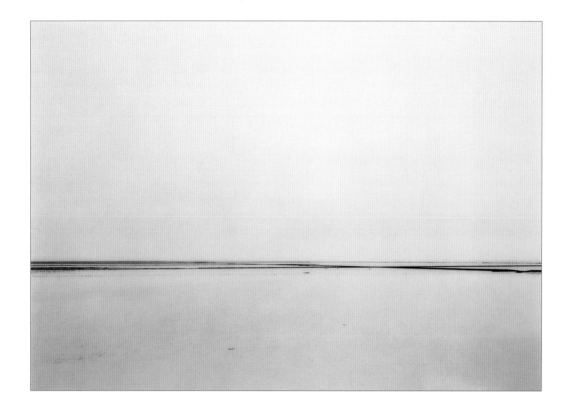

**ELGER ESSER**
(German, born 1967).
*Ameland Pier X,
Netherlands*, 2000.
Color print on Diasec face,
70⅞ x 93⅛ inches (180 x
236.5 cm). Sarah Norton
Goodyear Fund, 2003.

Elger Esser's photographs often present vast expanses of water, either on the ocean or along the shores of rivers. Works like *Ameland Pier X, Netherlands*, taken around the Frisian Islands off Holland's north coast, are about experiencing nature. Esser has commented, "I seek places, not to document them as such, but rather to use the encounter with them to make a picture."[3] In this work, the sky, the largest component, is mirrored in the still water, creating an effect of infinite space and reminding us of how small we really are in the vastness of the world. In Esser's work, however, we are not threatened by this vastness, but are instead comforted and calmed by its peace, quiet, and constancy. Esser's photographs rarely contain a human presence, and we are drawn to imagine ourselves standing alone where the artist stood, seeing, hearing, smelling, and even perhaps feeling what he did.

**HIROSHI SUGIMOTO** (Japanese, born 1948). *English Channel, Weston Cliff*, 1994. Gelatin silver print, edition 11/25, 16½ x 21¼ inches (41.9 x 54 cm). Charles Clifton Fund, 1996.

In his "Seascapes" series, Hiroshi Sugimoto explores the feeling of permanence in nature. Over a period of decades, the artist photographed various seascapes, each from a cliff top toward a horizon line, which divides the image equally between a gray sky and a still sea. Although it is sometimes obscured by mist or fog, the horizon line is key—the contact point between the earth and the air, the material and the spiritual, and the point at which the earth curves out of sight. The Gallery's Collection includes three works in this series: from Mt. Tamalpais, north of San Francisco; at Safaga on Egypt's Red Sea Coast; and off Weston Cliff on the English Channel, illustrated here. That these diverse geographic locations look almost identical reminds us that we all inhabit the same world. The long exposures Sugimoto often uses add an element of time to these scenes, suggesting another potential level of meaning. Although human beings have stood on these shores for millennia, the sea existed long before people walked the earth, and it likely will remain once we are gone.

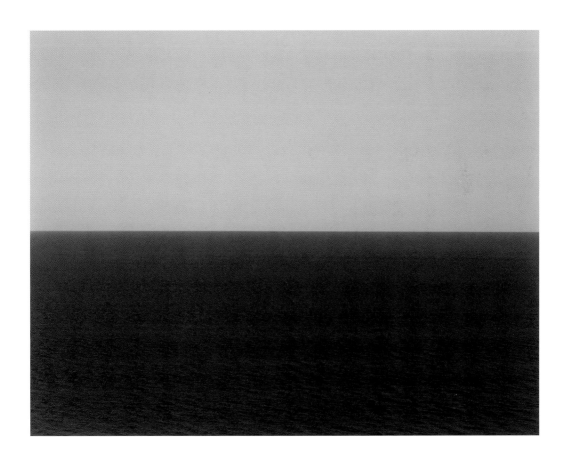

To create each of the large paintings that make up his "Flood" series, with their energetic swaths of red, Barnaby Furnas pours paint onto a canvas set on an incline and then manipulates it with brooms and spray bottles, creating a variety of effects. The titles of these works, including *Flood*, *Flood (Red Sea)*, *Red Sea (Closing)*, and *The Whale*, call up myriad examples of conflict and struggle: the Biblical flood that covered the earth; Moses' parting of the Red Sea and its closing on the Egyptian army; Herman Melville's *Moby-Dick*, a tale of obsession that ends in tragedy; and contemporary disasters like the devastating 2004 Indian Ocean tsunami and 2005's destructive Hurricane Katrina. Furnas has commented, "I think these big blood floods are absolutely timely. For some time, I've been doing battle pictures, and people shooting people, and now this—which is about as clear as I can get. It's about things going wrong, everything collapsing. In a way, that's reassuring, at least in painting, because there are no boundaries, there's no abstraction versus representation—everything can be both."[4]

**BARNABY FURNAS** (American, born 1973). *Flood*, 2007. Urethane on linen, 84 x 140 inches (213.3 x 355.6 cm). Sarah Norton Goodyear Fund, 2010.

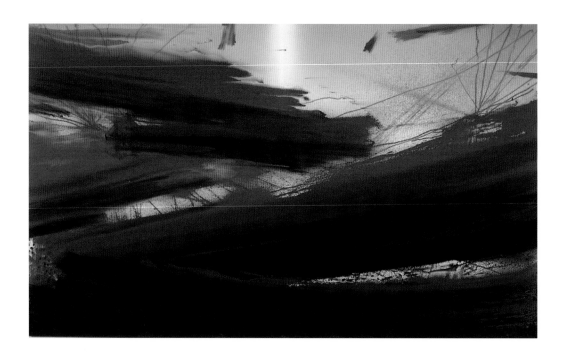

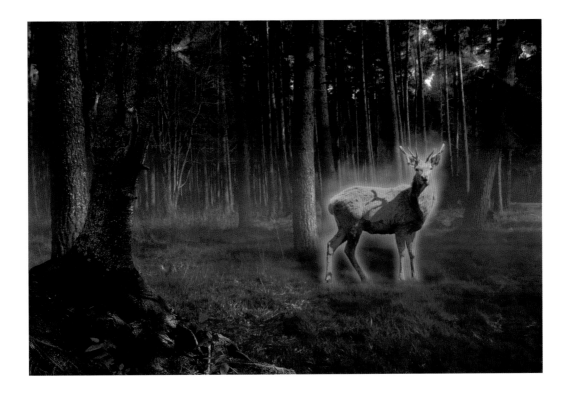

As we listen to the soothing sounds of the woods at twilight, a majestic glowing stag enters the scene, wanders around, at times looks right at us, then eventually wanders away. Does the stag's green glow imply that he is somehow magical, or has been adversely affected by some kind of human activity? Is he the "avenger" of the title? If so, what is to be avenged? The scene is not as simple as it might first appear. Kelly Richardson filmed the stag at the Jedforest Deer and Farm Park in Scotland, the landscape at Kielder Forest in England, and the foreground tree in Canada's Algonquin Provincial Park. The digital process she used to combine them took months and involved heavy color manipulation, added fog, and added light rays that "contradict the natural light in the image . . . alluding to another great light source." Richardson has commented that the title "references the fantastical worlds created in online gaming, where more and more people are opting to trade their 'real' life for one that is 'make believe.'"[5] Thus, perhaps the deer is simply a beautiful fantasy.

**KELLY RICHARDSON**
(Canadian, born 1972).
*Twilight Avenger*, 2008.
High-definition video,
edition 3/5. Running time:
6 minutes, 20 seconds.
Fellows for Life Fund, by
exchange, 2008.

The unusual atmosphere of *Failed Back* results, in part, from Clare Woods's process. She generally begins her paintings by going into the forest at night with her camera and flash gun, taking photographs of the ground, which in this case was partially covered with snow. Back in the studio, she combines these images into larger compositions, which she then turns into line drawings that become the bases for her paintings. Her use of enamel paint on aluminum results in the glossy effect. In this work, Woods creates the feeling of being in the woods at night—intriguing and compelling, but also potentially ominous. *Failed Back* was also important to Woods on a personal level. The title refers to health problems that required major spinal surgery, which left her immobilized for two months. She has said, "I spent a long time thinking about the painting and it became an obsession. My goal was to walk and get better so I could finish it. I feel that this is the most important work I have made to date and it marks a significant turning point in my work."[6]

**CLARE WOODS**
(British, born 1972).
*Failed Back*, 2004.
Enamel on aluminum,
130 x 315 inches
(330.2 x 800.1 cm).
Sarah Norton Goodyear
Fund, 2005.

**MATTHEW RITCHIE**
(British, born 1964).
*Morning War,* 2008.
Oil and marker on linen,
96 x 142⅞ inches (243.8
x 363 cm). Albert H.Tracy
and Charlotte A. Watson
Funds, by exchange, 2010.
Installed by Matthew Ritchie,
with Katharine Gaudy and
Christine Carr Miller.
In the foreground is Ritchie's
*The Holstein Manifesto,*
2008; polished aluminum,
tar, anodized brass, spent
bullet shells, Tarot cards,
digital animation, Perspex,
mirrored Perspex, and vinyl,
dimensions variable; Pend-
ing Acquisition Funds, 2011.

This three-part installation was born from Matthew Ritchie's belief that artists have a responsibility to "re-represent the universe . . . or parts of it." One of the main references in the painting *Morning War* is the clash between matter and antimatter that gave birth to the universe. Ritchie has commented that the rust-colored areas could be something either emerging from the chaos or being subsumed by it. The fallen tower, riddled with bullet impacts and surrounded by shell casings and Tarot cards, houses a video that follows the growth and destruction of a city. The wall drawing, which was cre- ated by the artist on site and unites the entire installation, reflects the division of the universe into more manageable parts. It includes the phrases *Division of the Heavens*, *Division of the Waters*, and *Division of the Bodies*, as well as the term *M Theory*, which is an extension of the complex string theory that proposes the existence of more than three dimensions. The lack of a definitive meaning reflects the artist's goal; as he has commented, "The point of this is to not close it down to one single reading, but to open it up to lots and lots of readings."[7]

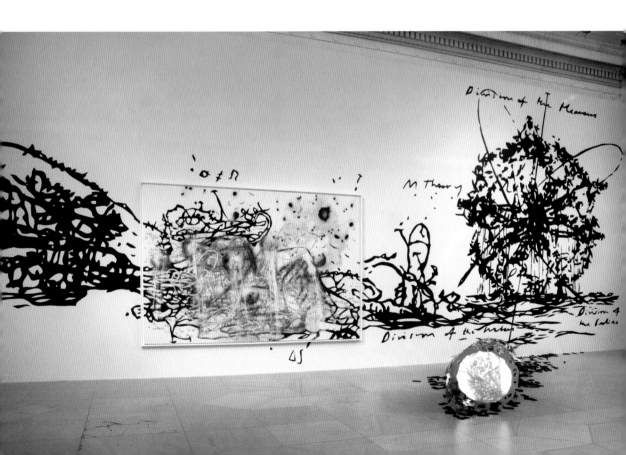

Jennifer Steinkamp wanted to work with nature, but she was not interested in being outdoors. Instead, she used her training in motion graphics and computer animation to create virtual nature—in this case, a unique species of tree generated by altering the bark, leaves, and branches of a maple. Steinkamp's tree flowers in the spring, is covered with green leaves in the summer that turn reddish-orange and yellow in the fall, appears bare in the winter, and then blooms again in a continuous cycle. The speed at which this happens is left up to the museum. One of Steinkamp's inspirations for this type of work is her fascination with "the beauty of real plants illuminated by artificial light during the evening." She finds that "what is most interesting . . . is the contrast between the natural and the manmade."[8] The title, *Dervish I,* refers to members of a Muslim order who spin while in a religious trance.

**JENNIFER STEINKAMP**
(American, born 1958).
*Dervish I*, 2004. Digital
projection, edition 1/1.
Edmund Hayes Fund, 2004.

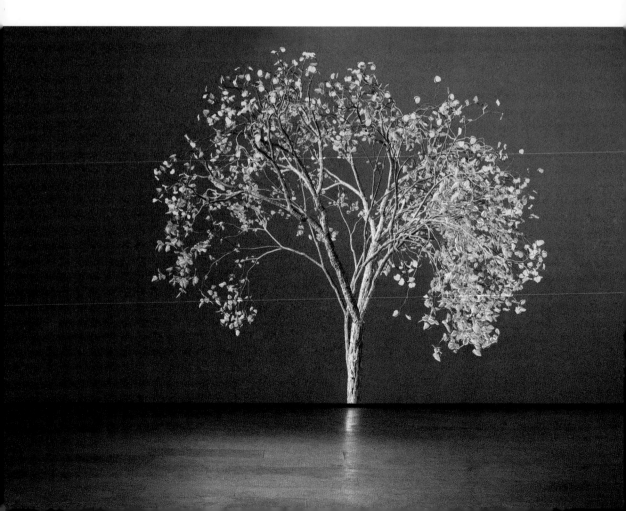

**NANCY GRAVES**
(American, 1939–1995).
*Camouflage Series #5,*
1971–74. Acrylic and oil
on canvas, 90 x 72 inches
(228.6 x 182.9 cm).
James S. Ely Fund, 1976.
Art © Nancy Graves
Foundation/Licensed by
VAGA, New York, NY.

Nancy Graves grew up in Pittsfield, Massachusetts, where her father worked at an art and natural history museum. It comes as no surprise, then, that from an early age she was fascinated with science and the natural world, and that, by age twelve, she knew she wanted to become an artist. Each of the five paintings in the "Camouflage Series" presents a different type of sea creature that survives by blending with its environment. Although this shimmery painting at first appears completely abstract, closer inspection reveals a school of fish, nearly indistinguishable from the mixture of rock, sand, and plants on the shallow ocean floor, an effect enhanced by the refraction of the sunlight as it penetrates the water. In spite of her interest in the natural world, however, Graves chose only those subjects that would achieve her artistic goals: "Art is the primary process. . . . The content must adapt itself to my concerns, which are primarily those of creating a new way of seeing."[9]

## THE BUFFALO CONNECTION

Numerous works included in the Gallery's Collection relate to Buffalo's history, landscape, and people. Lars Sellstedt's work shows horses on a towpath pulling a boat along the waterway that connected the end of the Erie Canal with the city. He included another sign of the changing times by contrasting the steamship tied at the dock with the sailing ship heading out onto Lake Erie in the distance. Buffalo's African American newspaper, *The Challenger*, is published on the city's East Side, where generations of Jacqueline Tarry's family have lived. In *Challenger*

**1**

**LARS SELLSTEDT**
(American, born Sweden, 1819–1911). *Buffalo Harbor from the Foot of Porter Avenue*, 1871. Oil on canvas, 18 x 30 inches (45.7 x 76.2 cm). Gift of Henry A. Richmond, 1878.

**2**

**MCCALLUM & TARRY**
(American, born 1966 and 1963). *Black Is Beautiful* from *Challenger Fragments Wall*, 2010. Oil on linen and toner on silk, 14¹/₁₆ x 21⁹/₁₆ x 2⅜ inches (35.7 x 54.8 x 6 cm). Charles W. Goodyear and Mrs. Georgia M. G. Forman Funds, by exchange, Gift of the Winfield Foundation, by exchange, Edmund Hayes Fund, by exchange and Charles W. Goodyear Fund, by exchange, 2011.

**3**

**ZHAN WANG**
(Chinese, born 1962). Detail of *Urban Landscape Buffalo*, 2005–10. Stainless steel pots, pans, and kitchen utensils, 67½ x 197 x 393⅜ inches (171.5 x 500.4 x 999.8 cm). George B. and Jenny R. Mathews Fund, by exchange, 2010.
(See also page 14.)

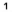

**1**

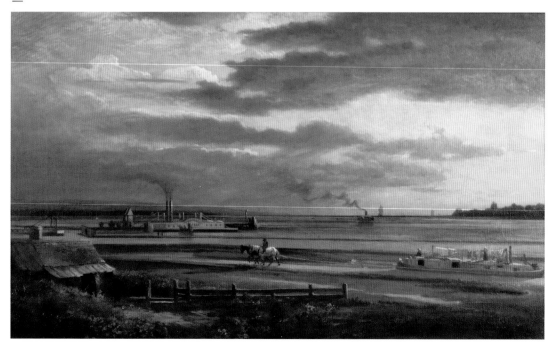

*Fragments Wall*, she and her partner Bradley McCallum combine photography with overlaid paintings on silk to create a mood of nostalgia and memory. Zhan Wang's commissioned work *Urban Landscape Buffalo*, although not a specific rendition, does contain suggestions of recognizable buildings, such as City Hall, the HSBC Tower, and Coca-Cola Field, home to the Buffalo Bisons. The mountain—not part of the landscape of Buffalo—is Wang's characteristic rendition of traditional Chinese "scholars' rocks," fantastically shaped rocks prized as symbols of the wonders of nature. Here they are intended, in part, to express the artist's concern about the fast-paced development in his native country and the resulting effects on its landscape and traditions.

3

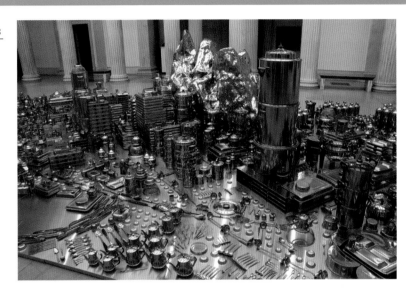

2

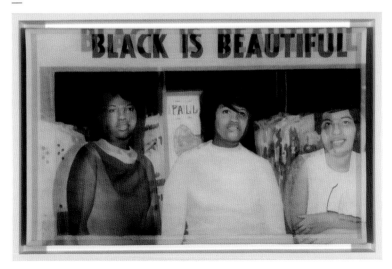

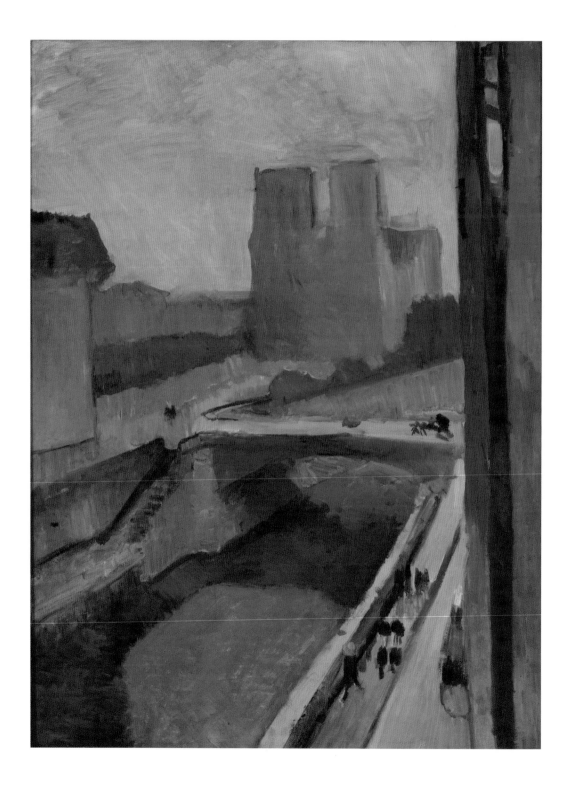

# CITY LIFE

Cities are often characterized by unique personalities, traditions, and lifestyles, depending on their age, climate, history, and inhabitants. Before photography, when travel was expensive, time-consuming, and often dangerous, curious individuals were able to see other parts of the world only through images created by artists. Cities are where artists generally congregate, and where we find most museums and galleries. Rome was the center of the international art world for many centuries; this eventually shifted to Paris and, after World War II, to New York. The works featured in this section present cities in a variety of ways—from literal representations, to the evocation of mood and a consideration of lifestyle.

**HENRI MATISSE**
(French, 1869–1954).
*Notre-Dame, une fin d'après-midi (A Glimpse of Notre Dame in the Late Afternoon)*, 1902.
Oil on paper mounted on canvas, 28½ x 21½ inches (72.4 x 54.6 cm). Gift of Seymour H. Knox, Sr., 1927.

This painting captures the view from Henri Matisse's apartment on Paris's Quai St. Michel, where he and his wife lived from 1899 until 1902. The Petit Pont, or Small Bridge, crosses the Seine at a narrow point on one side of the Ile de la Cité (City Island), on which sits the majestic Cathedral of Notre Dame. Matisse's goal was not to represent the scene in a realistic way, but rather to re-create the atmosphere, colors, and light of late afternoon. Traces of yellow remain in the sky as light fades and the city falls more and more into shadow. Everything is represented in a general rather than specific way—for example, the intricately carved façade of Notre Dame is painted in shades of primarily blues and purples, and people are just dabs of color as they walk along the quay. The work's positive and restful mood is one Matisse consistently tried to convey throughout his long career.

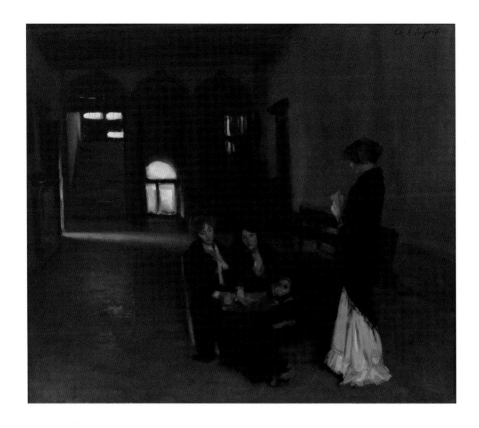

John Singer Sargent's views of Venice were very different from the brightly lit, colorful outdoor imagery most artists in the nineteenth century created, and the public of the time expected. Although some critics had positive things to say, the idea that Sargent's novel approach might be worth considering was not an opinion shared by most people, who felt that the shadowy indoor scenes were unhealthy, run-down, even threatening. *Venetian Bead Stringers* is typical of these works with its long hallway, the light that filters into the darkness from windows and doors, and the presence of several figures. Here, two women hold a tray for stringing beads; a third woman, who is more stylishly dressed, is perhaps a customer. Because his paintings of Venice were neither critical nor popular successes, Sargent gave many of them to friends. The Gallery's work went as a wedding gift to the artist Carroll Beckwith, who, with the artist's approval, sold it to the Albright Art Gallery in 1916.

**JOHN SINGER SARGENT**
(American, 1856–1925).
*Venetian Bead Stringers,*
1880 or 1882. Oil on canvas,
26⅜ x 30¾ inches
(67 x 78.1 cm). Friends of
the Albright Art Gallery
Fund, 1916.

Marsden Hartley moved frequently in an attempt to escape feelings of dissatisfaction and loneliness. In 1913, with the help of the American photographer and gallery owner Alfred Stieglitz, Hartley traveled to Paris, where he found himself attracted to the emotionally expressive nature of German art, prompting him to move to Berlin. This painting is, in one sense, a portrait of Berlin, where Hartley was extremely happy for one of only a few times in his life. The strength and discipline of Imperial Germany were frequently displayed at the time in military parades and pageants, which impressed Hartley and offered him the combination of crowds and solitude he had sought for many years. The imagery in *Painting No. 46* prominently features the Imperial colors—red, black, and white—and evokes banners, flags, and the details of military uniforms. Unfortunately, when Hartley was forced by food shortages to return to the United States in 1915, he was again faced with intense feelings of discontent.

**MARSDEN HARTLEY**
(American, 1877–1943).
*Painting No. 46*, 1914–15.
Oil on canvas, 39¼ x 32
inches (99.7 x 81.3 cm).
Philip Kirwen Fund, 1956.

Donald Sultan's painting of a factory on a grid of industrial tiles repre-
sents for the artist a contemporary landscape and reflects his explo-
ration of the relationship among the worlds of industry, nature, and
humanity. Sultan also established a link between industry and artmak-
ing; when viewed upside-down, the black area becomes an abstracted
artist's worktable. There are additional hidden images as well: a white
area that refers to a cigarette, a kind of human-scaled smokestack; and
two forms in the upper corners that are sideways hats, an image Sultan
often uses. About this piece, the artist has written, "It is an image of a
factory, a place embodying industry, creativity, and human labor, as well
as a remote shape in the picture that includes other images and impres-
sions. It is sooty-elegant, symbolic, and flat . . . . These motifs, a factory,
a cigarette, a work table, depth, landscape, emblem, strength, and air,
continue to haunt me and form the center of my interests."[1]

**DONALD SULTAN**
(American, born 1951).
*September 3, 1980
Building*, 1980. Oil, tile, and
graphite on wood, mounted
on Masonite, 48 x 48 inches
(121.9 x 121.9 cm). Gift of
Mr. and Mrs. Armand J.
Castellani, 1983.

In 1948, a *Look* magazine poll of art critics and museum directors voted John Marin "America's Greatest Artist." His primary medium was watercolor, which he used not to represent scenes exactly, but, rather, to almost paraphrase them. In this view of New York's Lower Manhattan, he expresses the energy and excitement of the city, which reflects his philosophy: "Shall we consider the life of a great city as confined simply to the people and animals on its streets and in its buildings? Are the buildings themselves dead? We have been told somewhere that a work of art is a thing alive. You cannot create a work of art unless the things you behold respond to something within you. Therefore, if these buildings move me, they too must have life. Thus the whole city is alive; buildings, people, all are alive."[2] Even the border—a device he frequently used to bring his scenes back under control at the boundaries—contains energy in its oval shape and the diagonal break at its lower edge. *City Construction* must have been a favorite of Marin's, as he kept it in his studio rather than offering it for sale.[3]

**JOHN MARIN**
(American, 1872–1953).
*City Construction*, 1932.
Watercolor and charcoal on
paper, 35 x 30 inches (88.9
x 76.2 cm). George Cary
Fund, 1954.

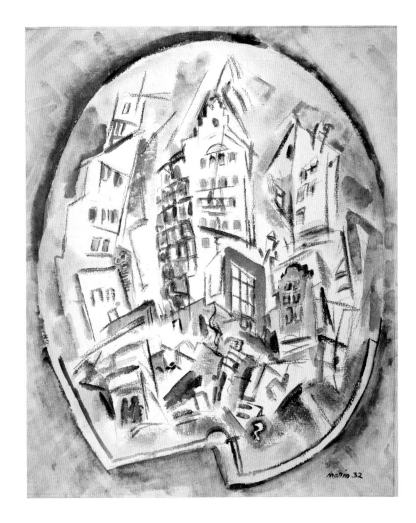

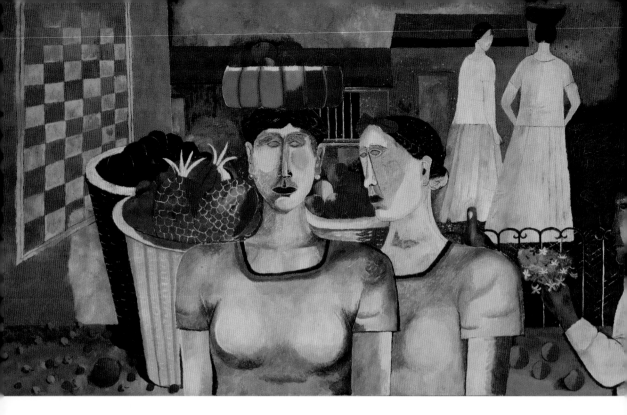

**RUFINO TAMAYO**
(Mexican, 1899–1991).
*Women of Tehuantepec,*
1939. Oil on canvas,
33⅞ x 57⅛ inches
(86 x 145.1 cm).
Room of Contemporary
Art Fund, 1941.

Octavio Paz, the Mexican poet and Nobel laureate, said of Rufino Tamayo, "If one word could express what it is that distinguishes Tamayo from the other painters of our time, I would unhesitatingly say *sun*. Visible or invisible, the sun is present in all his paintings."[4] The rich color of Tamayo's paintings is influenced by the people, art, and light of his native Mexico. He was born in Oaxaca to parents who were Zapotec Indians; after they died, the eight-year-old Tamayo went to live with his aunt in Mexico City. When he spent too much time in school drawing rather than studying, she put him to work in her fruit stand. That memory, with its sights, sounds, and smells, comes through in this painting of the marketplace in the city of Tehuantepec, which is near Oaxaca. The Zapotec women in Tehuantepec, featured here, are called Tehuanas, known for their colorful dresses, their assertiveness, and their beauty.

Eugène Delacroix was one of the first Europeans ever to walk the streets of Meknes, the former capital of Morocco. He was there at the invitation of the French king's goodwill ambassador, Count Charles de Mornay, who, in the age before photography, asked Delacroix to visually document his diplomatic mission to the sultan of Morocco. The sultan granted the group permission to wander the city, but due to the expense of a guide and the potential risk, Delacroix was the only member of the party who chose to do so. As he explored the streets, he made sketches of the city's architecture, culture, and inhabitants. In *Street in Meknes*, which is a composite of various sketches, the Islamic-style arch and window, the pottery and textiles in the alcove, and the costumes provide a glimpse into Moroccan life and culture. The curiosity with which Delacroix viewed the residents was matched by their intense study of him. Today, when we can find images of almost any place in the world in a matter of seconds, it is difficult to imagine the curiosity Europeans would have felt about an exotic city and culture that very few Westerners had ever seen.

**EUGÈNE DELACROIX**
(French, 1798–1863).
*Street in Meknes,*
1832. Oil on canvas,
18¼ x 25¼ inches
(46.4 x 64.1 cm). Elisabeth
H. Gates and Charles W.
Goodyear Funds, 1948.

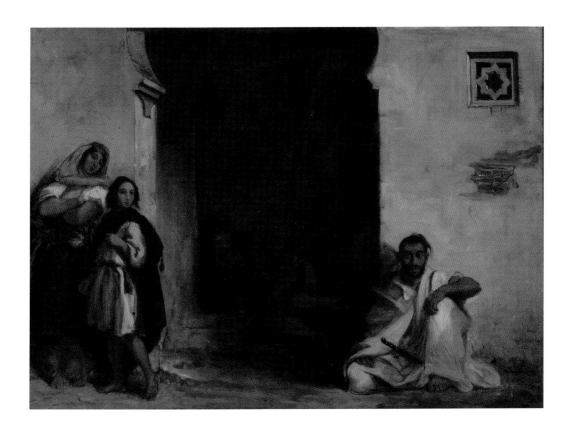

The *Spectrum of Hackney Road I* is named for the street where David Batchelor's London, England, studio is located. Batchelor, who focuses on contemporary sources of light and color in urban areas, has stated, "Our cities are saturated with glowing, flashing, colored light, and innumerable brilliant, shiny, or fluorescent surfaces. This for me is where color begins . . . in the swatch books for commercial paints, lighting gels, neon, and Plexiglas."[5] He collects his artistic materials from the streets and from salvage companies, in part to draw attention to overlooked parts of the city. He does not change the found objects much—in this case, inspired by a trend in England of lighting the undercarriages of cars to reflect colors onto the streets, he attached fluorescent lights to the undersides of industrial dollies. Because these transformed vehicles are called "pimped-up" cars, Batchelor called his creations "pimped-up dollies."

**DAVID BATCHELOR**
(Scottish, born 1955). *The Spectrum of Hackney Road I*, 2003. Found objects, fluorescent light, and cable, dimensions variable. Harold M. Esty, Jr. Fund, 2004.

**PHILIP-LORCA DICORCIA**
(American, born 1951). *Head
#6*, 2001. Fujicolor Crystal
Archive print, edition of
10, 48 x 60 inches (121.9
x 152.4 cm). Sarah Norton
Goodyear Fund, 2001.

To create his series "Heads," Philip-Lorca diCorcia marked an X on the
sidewalk in New York's Times Square and waited at a distance with a
long lens. When someone stepped on the X, he took a picture, and the
camera shutter remotely triggered a strobe flash mounted on a nearby
pole that blacked out almost all of the surrounding detail. People who
appear together in the images most likely did not know each other.
Here, the man in the suit stepped on the X; the younger man was simply
walking close enough to be partially lit as well. Although the subjects
of the "Heads" series are diverse, reflecting New York's population,
they have something in common in their facial expressions, which seem
thoughtful and closed in, perhaps in an attempt to create a psychologi-
cal space in a place where they have little physical space. As diCorcia
said, "The street does not induce people to shed their self-awareness.
They seem to withdraw into themselves. They become less aware of their
surroundings, seemingly lost within themselves."[6]

The title and shape of Tony Smith's large, outdoor steel work came from the dissatisfaction he felt with a model that, he noted, "had the look of a war memorial. Stripping away everything but the spine, I wound up with a cigarette from which one puff had been taken before it was ground out in the ashtray."[1] Rachel Whiteread's *Untitled (Domestic)* can only be displayed at the Albright-Knox in the Greek Revival–style

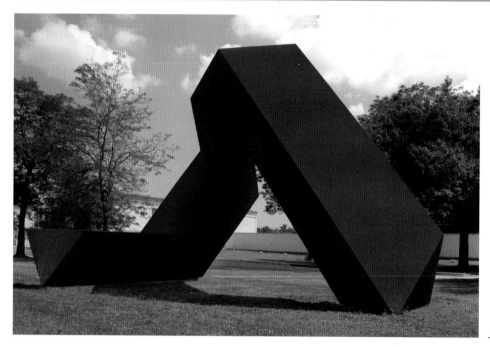

**1**

**1**

**TONY SMITH**
(American, 1912–1980). *Cigarette*, 1961–67. Cor-Ten steel, 180 x 216 x 312 inches (457.2 x 548.6 x 792.5 cm). Gift of The Seymour H. Knox Foundation, Inc., 1968.

**2**

**RACHEL WHITEREAD**
(British, born 1963). *Untitled (Domestic)*, 2002. Mixed media, 266⅛ x 229⅞ x 96½ inches (676 x 583.9 x 245.1 cm). Owned jointly by Albright-Knox Art Gallery, Buffalo; George B. and Jenny R. Mathews Fund and Carnegie Museum of Art, Pittsburgh; The Henry L. Hillman Fund, 2006. Also pictured is Clyfford Still's *1957-D No. 1*, 1957. Oil on canvas, 113 x 159 inches (287 x 403.9 cm). Gift of Seymour H. Knox, Jr., 1959.

**3**

**LIZ LARNER**
(American, born 1960). *2001*, 2001. Fiberglass, stainless steel, and automotive paint, edition 1/3, 144 x 144 x 144 inches (365.8 x 365.8 x 365.8 cm). George B. and Jenny R. Mathews Fund, by exchange, and Sarah Norton Goodyear Fund, 2006.

Sculpture Court, where it blends with, yet dominates, the space. The unusual appearance of the stairs in this work resulted from Whiteread's use of casts of the negative (empty) space under and around a fire escape on a building in London, rather than actual stairs. Liz Larner's immense sculpture dominates almost any space it inhabits and draws viewers in with its size, color, and form. The energy of the work is enhanced by its surface of green and purple iridescent urethane paint, which seems to change color as viewers walk around the sculpture.

2

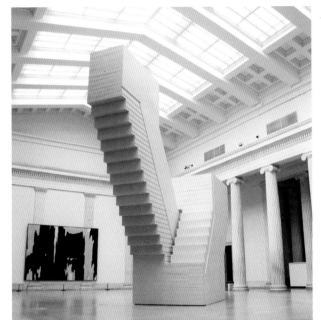

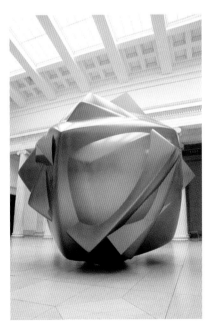

3

People spend a lot of time indoors, sometimes by choice and at other times because they have no other option. Interior spaces can offer many positive things: home; shelter; warmth or coolness; a comfortable place to sit down and relax; a spot to make purchases or eat meals; and a place to learn, earn a living, or spend leisure time watching a sporting event, film, or performance. On the other hand, being forced to spend time inside can be frustrating, especially if one is not physically able to go outside without help, or is confined to a hospital or a prison. This section features works by artists who consider interiors from many different perspectives, often creating distinctive inner spaces that are all their own.

**FRED SANDBACK**
(American, 1943–2003).
*Untitled (Sculptural Study,
Four-part Vertical
Construction)*, ca.
1982/2004. Red acrylic
yarn, ceiling height
x 24 x 96 inches (ceiling
height x 61 x 243.8 cm).
Albert H. Tracy Fund,
by exchange, 2007.

Fred Sandback's yarn installations not only transform the areas they inhabit, they challenge viewers' perceptions of space, as well. The specific location of a Sandback piece is very important, because the height of the ceiling, the size of the room, and the colors of the surrounding works of art greatly contribute to its overall effect. For example, the red yarn that makes up the Gallery's work stands out more vividly against the backdrop of a dark painting than it does against a light-colored work. Early in his career, Sandback also used materials such as wire and metal rods, but he soon decided he preferred yarn because it did not create a rigid line like metal, and it absorbed, rather than reflected, light. As viewers walk around this subtle sculpture, they are often reminded of the feeling of specific spaces such as passageways and doors. This feeling of open space reflects Sandback's desire to make sculpture that does not have an inside.[1] However, he has also pointed out that "Illusionistic art refers you away from its factual existence toward something else. My work is full of illusions, but they don't refer to anything."[2]

**PETER HALLEY**
(American, born 1953).
*Over the Edge*, 1992.
Dayglo acrylic, acrylic,
and Roll-A-Tex on canvas,
90 x 93 inches (228.6 x
236.2 cm). Seymour H.
Knox Memorial Acquisition
Fund, 1992.

When Peter Halley moved back to his native New York after earning
a BA from Yale University and an MFA from the University of New
Orleans, he felt isolated and alone. The brick walls he began paint-
ing soon became prison cells, which then evolved into more general,
windowless cells like the one seen in *Over the Edge*. Not only were these
more optimistic than prison cells, they were also more versatile because
they had the potential to inspire parallels with other cellular objects, like
battery cells, or the cell structure of the human body. The conduits seen
emerging from the cells were inspired when Halley was working at home,
listening to music, talking on the phone, and using electricity, water, air
conditioning, and so on. He thought about the fact that even when a
person is alone and isolated, he or she is still connected to the world in a
variety of ways. It is not surprising that Halley was thrilled with the devel-
opment of cell phones, which fit perfectly into his construct of the world.

Andreas Gursky's work is about people and space. His images always depict things we recognize, and they are always clearly focused. Gurksy's subjects exist in the real world and serve as starting points for his photographs, but how he subsequently manipulates his images is unknown. Cold and impersonal spaces such as this one can be seen as a reflection of the anonymous, slick, and fast-paced contemporary world. There is no diversity in this type of interior—railings, doors, concrete planters, benches, and carpeted hallways are repeated, seemingly endlessly. Housekeeping carts appear, but they are so small in the vastness of the setting that they cannot add any real human presence. Although we understand what this and similar works by Gursky imply about our society, his images are nonetheless often enticing, even beautiful.

**ANDREAS GURSKY**
(German, born 1955). *Atlanta, 1996*, 1996. Color print, 74 x 102½ inches (188 x 260.4 cm). Castellani Family Fund, 1998.

Although this photograph by Gregory Crewdson includes numerous details, any possible narrative is extremely enigmatic and becomes less clear the longer you look. Crewdson blurs the distinction between reality and fiction by using large production crews to build elaborate stage sets for his photographs. He works with local populations in various small communities, usually suburban or rural, to produce series like "Twilight," which was created in and around Lee, Massachusetts, between 1998 and 2002. The combination of the unique qualities of twilight and the often inexplicable actions of his figures results in unsettling images that convey an eerie sense of stillness and mystery. Crewdson has explained, "This idea of creating a moment that's frozen and mute, that perhaps ultimately asks more questions than it answers, proposes an open-ended and ambiguous narrative that allows the viewer to, in a sense, complete it. Ultimately, I'm interested in this ambiguous moment that draws the viewer in through photographic beauty, through repulsion, through some kind of tension."[3]

**GREGORY CREWDSON**
(American, born 1962). *Untitled (boy with hand in drain)* from the series "Twilight," 2001–02. Digital print, edition 4/10, 53 x 65 inches (134.6 x 165.1 cm), framed. James S. Ely Fund and funds in memory of Peggy Balbach, 2004.

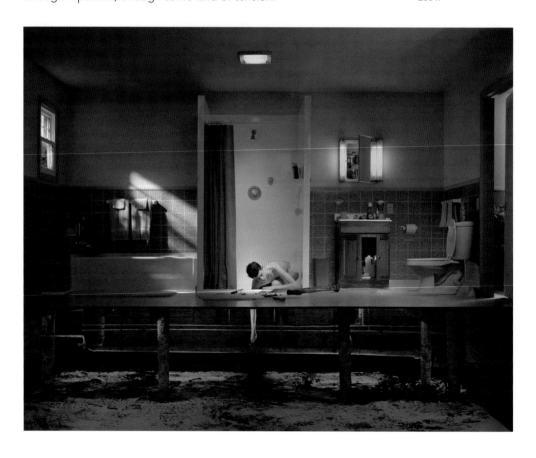

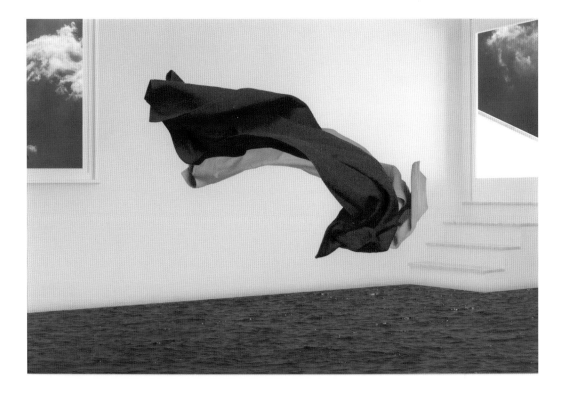

**JOHN MASSEY**
(Canadian, born 1950).
*Bitch's Brew* from the series
"After Le Mépris," 2010.
Archival digital color print,
edition 1/4, 21½ x 32 inches
(54.6 x 81.3 cm). Pending
Acquisition Funds, 2011.

In *Le Mépris (Contempt)*, the screenwriter and director Jean-Luc Godard
drew a parallel between a fictional narrative and his own failing marriage.
In the film, Camille Javal (Brigitte Bardot) becomes increasingly distanced
from her husband Paul (Michel Piccoli). In his series "After Le Mépris,"
John Massey focuses on a central scene from the film—a quarrel that
takes place between the Javals in a modern, white apartment on the is-
land of Capri. To create the pristine interiors in his photographs, Massey
built a small reproduction of the apartment in *Le Mépris* by watching
the film numerous times and counting the steps taken by the actors. The
white spaces, combined with bright blue sky or water, and punctuated
with vivid red and yellow objects, create a surreal mood and suggest a
narrative to viewers, even if they are not aware of the images' cinematic
source. Massey has discussed the series in terms of relationships that
have ended: "I . . . think there's something strangely iconic on a domes-
tic level about the pictures. They're so simple, but they're reminders . . .
of the messes, or plans, or foolish thoughts, or great thoughts, we all
have in these circumstances."[4]

When asked how she would like her work to affect viewers, Pipilotti Rist laughed and responded, "I want them to have reactions I can't predict."[5] Unlike Rist's large multimedia installations that envelop viewers in fantastical worlds, *All or Nothing (alles oder nichts)* is a quiet and intimate work presented in a comforting, semi-dark exhibition space. The centerpiece is a small, three-screen video projection of mesmerizing kaleidoscopic effects. Reminiscent of an altar, the shelf below holds a vase of bright yellow flowers, plates of grain, a dish of candy, and a water cooler from which visitors are invited to help themselves. A recycling receptacle is also available for used water cups. As Albright-Knox Curator for the Collection Holly E. Hughes has noted, "These sorts of offerings are meant to activate the relationship between the corporal and spiritual realms, by igniting an exchange between the acts of taking and giving."[6]

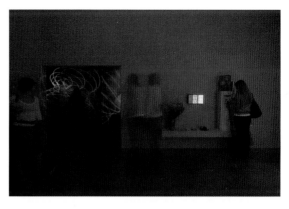

**PIPILOTTI RIST**
(Swiss, born 1962). Detail (below) and installation view (above) of *All or Nothing (alles oder nichts)*, 2010. Video installation: metal triptych with three LCD screens and three integrated players, edition 3/5, 9½ x 16⅞ x 3⅞ inches (24.1 x 42.9 x 9.8 cm). Bequest of Arthur B. Michael, by exchange, 2010.

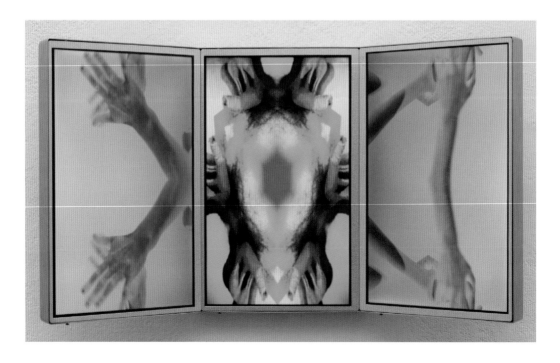

**ERWIN WURM**
(Austrian, born 1954).
*Jakob/Big Psycho VII*,
2010. Aluminum and paint,
edition 5/6, 47¼ x 15⅜ x
42⅛ inches (120 x 39 x
107 cm). Pending Acquisi-
tion Funds, 2011.

Many of Erwin Wurm's sculptures are both humorous and strange. When asked how a figure like this, which "wears" a sweater in an unorthodox way, came about, Wurm commented, "I asked a person to take a sweater and put it on as I told him. These forms came out and then we cast it. It transformed very easily into something else. . . . I made a series about this aspect with clothes because it's about hiding—you see a human being but you don't see the face, so it's not related to any person or personality." The anonymous nature of this work makes it universal, relating to how we all cover ourselves as a form of protection—in physi-cal things such as clothing, houses, and cars, and also through various psychological means. Although figures like this can be amusing, Wurm has commented, "I never make things just to make funny things. I make things on a certain level to create insecurity and question marks in the relation to [viewers'] daily life, to our psychology, to our social issues."[7]

In the ten works that make up his "Tablada Suite," 1991–97, Guillermo Kuitca explored various types of public spaces. Each painting illustrates the floor plan of a building, including a hotel, a hospital, an arena, a theater, and, in the case of the Gallery's *Tablada Suite VI*, a prison. In structures like these, large numbers of individuals come together and share a common experience while remaining, for the most part, anonymous and isolated from one another in their seats, rooms, or cells. Kuitca derived most of the images in the "Tablada Suite" from existing architectural plans. But, unable to find a prison diagram that created the nightmarish quality he was seeking, he designed this institution himself. Devoid of open spaces like a cafeteria, exercise yard, and common areas, Kuitca's prison consists solely of narrow and claustrophobic hallways lined with small and cramped cells, all surrounded by a solid wall that would allow no visual contact with the outside world.

**GUILLERMO KUITCA**
(Argentine, born 1961).
*The Tablada Suite VI*, 1992.
Graphite and acrylic on canvas, 78¾ x 78¾ inches (200 x 200 cm). Edmund Hayes Fund, 1994.

**GEORGES SEURAT**
(French, 1859–1891).
*Study for Le Chahut*,
1889. Oil on canvas,
33¾ x 30⅜ x 4½ inches
(85.7 x 77.1 x 11.4 cm),
framed. General
Purchase Funds, 1943.

*Study for Le Chahut* is set in a dance hall in Montmartre, a Parisian neighborhood known for its entertainment venues and bohemian artistic atmosphere. Dance halls were a relatively new phenomenon at the end of the nineteenth century and were, therefore, a source of curiosity for members of the middle class—the man sitting in the lower right corner has presumably ventured out to observe this alternative lifestyle. The *chahut*, also known as the *quadrille*, was a deliberately provocative dance in which men demonstrated their skill and strength through acrobatic move-ments while women kicked their legs high in the air to reveal what was underneath their skirts. In this painting, the performers are completing the dance, thanking the audience with raised legs and tipped hats. Paul Signac, who painted in a similar style, wrote that he and Georges Seurat were aligned with the working class and anarchy by exposing "the pleasures of decadence: balls, *chahuts*, circuses, [especially] as done by Seurat, who has so vivid a sense of the degradation of our era of transition."[8]

# FULL CIRCLE

The circle is filled with potential symbolism, representing concepts such as wholeness, infinity, unending cycles, perfection, and much more. Mariko Mori's "Connected World" works seem both infinite and intimate, and reflect the artist's belief in the Buddhist principle that everything in the universe is interconnected—human beings, nature, and all other

1

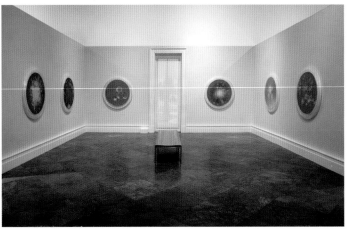

1

**MARIKO MORI**
(Japanese, born 1967). Installation view of *Connected World (Photopaintings I–VI)*, 2002. Dye destruction print and Lucite, edition 3/3, 3 inches (7.6 cm) deep, 48 inches (121.9 cm) diameter. George B. and Jenny R. Mathews, Edmund Hayes, and Charles W. Goodyear Funds, 2005.
**ABOVE:** *Photopainting III.*

forms of life. Through her work, Mori hopes to create a world that invites us to experience "a deeper consciousness in which the self and the universe become interconnected."[1] To create his delicate bubble drawings, Roland Flexner mixed Japanese sumi ink with soapy water and blew it through straws and hollowed brushes. When he gently burst the bubbles onto paper, he created effects that, like Mori's photopaintings, range from the microcosmic to the macrocosmic.

**2**

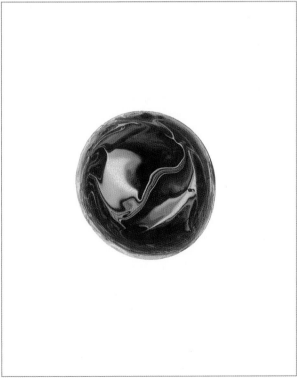

**2**
**ROLAND FLEXNER**
(French, born 1944). Installation view of thirty untitled Ink Bubble Drawings, 2001. Ink on paper, 6¾ x 5½ inches (17.1 x 14 cm) each. Gift of Mrs. George A. Forman, by exchange, 2010.
**RIGHT:** *Untitled.*

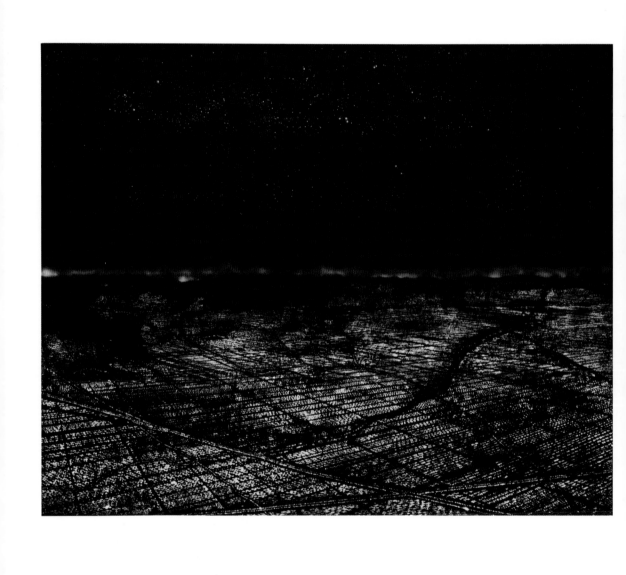

The relationship between humans and the natural world is one of the oldest themes in art, reflected by its appearance in hunting scenes on prehistoric cave walls. We are inextricably linked with the elements—earth, air, fire, and water—and our fates are tied to theirs. As people have gained more control over various aspects of the environment, we have also put a greater emphasis on ecology and conservation, which today can no longer be delayed or ignored. This selection of works in the Gallery's Collection features diverse approaches to the relationship between humans and nature, including characteristics that we share, mysteries that we have not yet unraveled, and how nature, while it often comforts and uplifts us, also has the potential to destroy us.

**SONJA BRAAS**
(German, born 1968).
*The Quiet of Dissolution,
Firestorm*, 2008. Color
print, edition 8/8,
62½ x 78½ inches
(158.8 x 199.4 cm).
Philip J. Wickser Fund,
by exchange, 2009.

One of the primary themes of Sonja Braas's series "The Quiet of Dissolution" is human perception of natural disasters. The artist has explained, "Natural disasters per definition only exist because of human presence. Destructive forces are essential for development, nature's existence is based and dependent on catastrophic, sudden changes. These necessary processes lead to destruction of human environment and thus to the catastrophe. The transition of when nature is perceived and revered as sublime and when feared as destructive depends on several aspects, among them physical distance, and whether exposure is by choice and temporary."[1] By that definition, this scenario, with its immense fire ready to engulf Los Angeles, qualifies as a natural disaster. The only recourse for humans in the face of a threat of this magnitude is to attempt to escape. Not to worry, however—this is not a real disaster, but a photograph of a model Braas created in her studio.

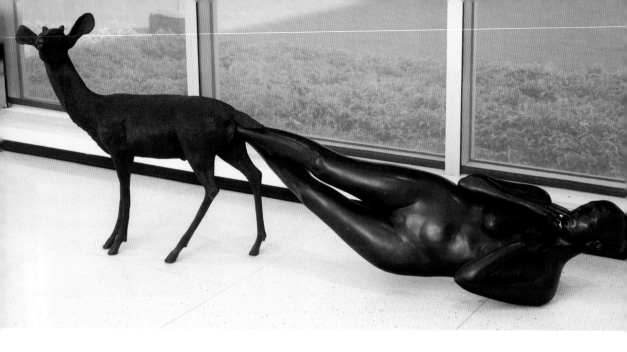

Kiki Smith once stated that 99 percent of her work is psychological, which opens it up to many possible interpretations. Here, a relatively small deer, who does not look the least bit concerned, gives birth to a fully grown woman. The combination of woman and deer, along with the idealized, classical style of both figures, evokes Diana, the ancient Roman goddess of the hunt, who is often depicted accompanied by a deer. Deer also feature prominently in the spiritual beliefs of a number of Native American cultures, reflecting the importance of our ties to the natural world. This theme is very important to Smith as well, who once stated, "The fate of humankind is intimately interconnected with the health of the environment."[2] If we destroy the environment, symbolized in this work by the deer, we, too, will cease to exist. Smith is not trying to teach a specific lesson: "I'm not trying to make didactic work that has literal interpretations. . . . I try to be as vague as possible! I want things to be open. I don't want to tell people how to think."[3]

**KIKI SMITH**
(American, born 1954).
*Born*, 2002. Bronze, edition
2/3, 39 x 101 x 24 inches
(99.1 x 256.5 x 61 cm). Sarah
Norton Goodyear Fund,
2002.

Ernesto Neto once stated, "My work speaks of the finite and the infinite, of the macroscopic and the microscopic, the internal and the external."[4] Viewers are often reminded of both the natural world and the human body when considering Neto's organic creations. The forms in this work, for example, might call to mind a constellation of stars in the night sky, coral in the oceans, a minute object seen through a microscope, or the cell structure or brain patterns of the human body. Capturing a feeling of potential movement is also important to Neto, as is the idea of skin. Here, Lycra tulle, often used for lingerie and bathing suits, covers pieces of Styrofoam like a kind of membrane. All of these qualities are encompassed in the overriding theme of Neto's work, which is life: "Life is something extreme, you know? . . . Life is very difficult to begin, but once it's started it's very difficult to stop. Changes happen all the time in the microscopic structure of every living being. Our bodies consist of four million cells, and that means four million micro-organisms inside of us. . . . All of my work is about that."[5]

**ERNESTO NETO**
(Brazilian, born 1964).
*Citoanima Demopylea,*
2003. Lycra tulle, Styrofoam,
and wooden pegs,
202 x 122 x 4 inches
(513.1 x 309.9 x 10.2 cm).
George B. and Jenny R.
Mathews Fund, 2005.

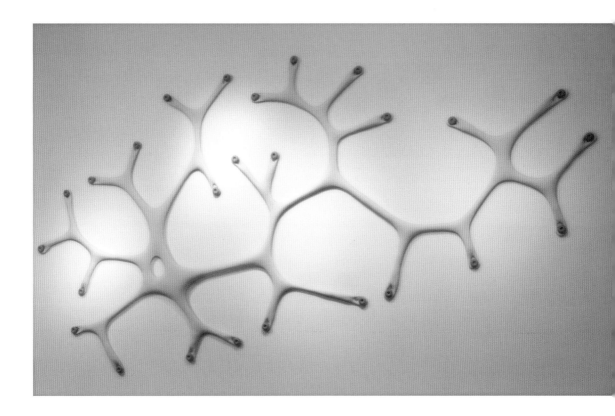

Bruce Nauman lives on a ranch in New Mexico, where he trains horses in addition to creating art. *Green Horses* is one of Nauman's first projects to combine these two practices. In the work, three projections—one large image on the wall and two smaller images on monitors—present Nauman riding a young horse in circles as part of the training process. The images are sometimes positive and sometimes negative, appear both right-side up and inverted, and have either magenta or green casts. The connection and unity of motion demonstrated between horse and rider resulted, in part, from Nauman's consultations with the famous trainer Ray Hunt, whose unconventional ideas for "breaking" a horse focused not on domination, but on an understanding of the close relationship between animal and human nature. What Nauman learned from Hunt, who died in 2009, helped him with both his horse-training abilities and his studio work. Nauman has said of Hunt, "Until I met him, I never met anyone who talked that way. . . . It's very subtle. There's softness, as a human. It has a lot to do with knowing how the body works."[6]

**BRUCE NAUMAN**
(American, born 1941). *Green Horses*, 1988. Two color monitors, two DVD players, one video projector, two DVDs, and one chair. Running time: 59 minutes, 40 seconds. Purchased jointly by the Albright-Knox Art Gallery, with funds from the Bequest of Arthur B. Michael, by exchange, 2007 and the Whitney Museum of American Art, New York, with funds from the Director's Discretionary Fund and the Painting and Sculpture Committee.

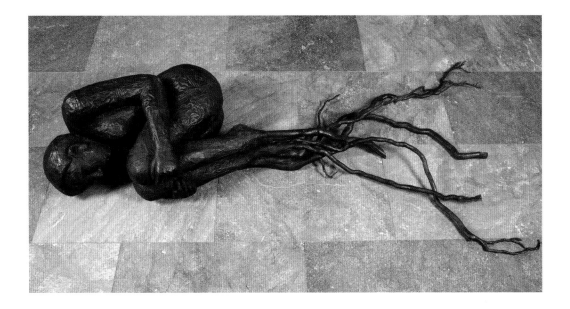

**ALISON SAAR**
(American, born 1956).
*Bareroot*, 2007. Wood,
bronze, ceiling tin, and
tar, 17 x 81 x 48 inches
(43.2 x 205.7 x 121.9 cm).
Charles Clifton Fund, by
exchange, 2008.

Alison Saar's experience growing up in a biracial family in the 1960s was
a major influence on her art, and, as a result, the primary themes she
addresses are how we view ourselves and how we are seen by others.
Although she has commented that much of her work includes "issues of
gender, race, [and] the economy," she has also said that "People bring
their own personal experience to it and understand it through a slightly
different lens. Sometimes I feel that their experience is more power-
ful than my ideas for it." Saar prefers using old and recycled materials
because of the history they preserve. To create *Bareroot*, she carved the
figure in wood and covered it with tin ceiling tiles that were then coated
with tar. The effect is akin to the scarification practices of many cultures,
especially in Africa. She cast the roots in bronze and then attached them
to the figure. Saar explained that *Bareroot* asks "how a people who have
been consistently uprooted and denied ownership of the land, relate
to the land?"[7] Although this question has a specific reference to African
American experience, it also carries universal implications about the in-
teraction of different cultures with one another and with the environment.

Edith Dekyndt investigates natural phenomena as she explores the relationship between art and science and encourages us to contemplate the ephemeral aspects of our world. In her three "Provisory Object" works, Dekyndt used human hands, soap bubbles, and temperature as her media. The patterns and colors seen in the video works were created solely by the environment; the length of each film was determined by how long each soap bubble lasted. *Provisory Object 01* was filmed in Belgium at 60.8 degrees Fahrenheit, resulting in slowly moving, graceful patterns of color. *Provisory Object 02* was recorded in Canada at a temperature of -4 degrees Fahrenheit. In this work, the water thickened quickly, broke, and folded over the hands. The third work was recorded at 77 degrees Fahrenheit in the Republic of Congo, where a smaller field was provided to help compensate for the higher temperature. This bubble, with its quickly moving colors and eddies, lasted for the shortest length of time. In spite of the experimental nature of this project, Dekyndt's quiet, delicate work is as poetic and subjective as it is scientific.

**EDITH DEKYNDT**
(Belgian, born 1960).

*Provisory Object 01*, 1997. DVD projection, edition 7/10. Running time: 2 minutes, 29 seconds.

*Provisory Object 02*, 2000. DVD projection, edition 7/10. Running time: 1 minute, 55 seconds.

*Provisory Object 03*, 2004. DVD projection, edition 7/10. Running time: 1 minute, 57 seconds.

Pending Acquisition Funds, 2011.

In 1969, Neil Jenney created a number of works similar to *Saw and Sawed*, with bright green backgrounds, recognizable imagery, and the title painted directly on the frame. He commented, "Titles are crucial. They add to the visual expression, the literary realm."[8] This reference to the literary realm implies that a story is being told—but Jenney leaves us to tell it, based on our own opinions and experiences. Many of his titles, like this one, have to do with simple cause and effect. The saw cut down the tree. However, because a chainsaw cannot accomplish that on its own, the artist implies a human presence as well. If the chainsaw is sitting in someone's backyard, it might be considered a useful tool. But if the chainsaw is in the middle of an unwisely deforested mountainside, or in a depleted area of rainforest, the interpretation might be quite different. Jenney leaves it up to us.

**NEIL JENNEY**
(American, born 1945).
*Saw and Sawed*, 1969.
Acrylic on canvas, 59¾ x
58½ inches (151.8 x 148.6
cm), framed. George Cary,
Mildred Bork Connors,
Harold M. Esty, Jr., Sarah
Norton Goodyear, George
B. and Jenny R. Mathews,
Albert H. Tracy and General
Purchase Funds, 1992.

SAW AND SAWED

Henry Moore made the first of his numerous reclining figures in 1924. He was attracted to the theme, he explained, because "the reclining figure gives the most freedom, compositionally and spatially" and because it can "recline on any surface. It is free and stable at the same time."[9] Eventually Moore began to see parallels between his reclining figures and landscape. Thus, the Gallery's work can be viewed in two ways. On one hand, it is a graceful female figure, with recognizable head, neck, shoulders, and breasts, leaning on one arm. The sculpture also includes a prominent navel before dividing into two highly abstracted legs. At the same time, the forms could be interpreted as hills, valleys, or rock formations. The overall organic effect was created through the use of elm, the wide grain of which Moore liked and skillfully utilized to echo and enhance the forms.

**HENRY MOORE**
(British, 1898–1986).
*Reclining Figure*, 1935–36.
Wood, 19 x 36¾ x
17½ inches (48.3 x 93.3
x 44.5 cm). Room of
Contemporary Art
Fund, 1939.

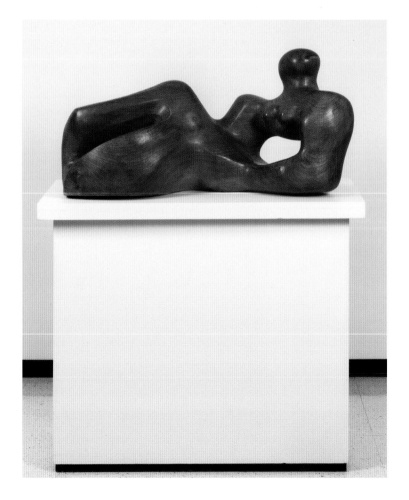

**BILL VIOLA**
(American, born 1951).
*The Messenger*, 1996.
Sound and video installation,
edition 3/3. Running time:
28 minutes, 28 seconds.
Sarah Norton Goodyear
Fund, 1996.

The Chaplaincy to the Arts and Recreation in North East England selected Bill Viola to create a work for Durham Cathedral because, as Chaplaincy member Bill Hall commented, "In his work we glimpse mystery through the ordinary and everyday, the transcendent through the immanent."[10] The choice was an interesting one, as Viola is not a Christian. Instead, he searches for universal truths that are part of many belief systems and hopes his art will invite contemplation of these spiritual mysteries. The techniques he uses include large scale, slow motion, and compelling sound effects. *The Messenger* begins with, as Viola describes it, "a small, central, luminous, abstract form shimmering and undulating against a deep blue–black void."[11] This form moves slowly toward the viewer, who can eventually discern a naked male figure. When the man reaches the surface, he opens his eyes and breathes out, releasing what Viola has called a "forceful primal sound of life."[12] The man then closes his eyes, takes a breath, and fades back into the depths, where the cycle begins again. While this work might remind Christians attending services at Durham Cathedral of baptism, many spiritual beliefs incorporate water as an element of transformation and transcendence.

It has been said that eyes are the mirrors of the soul, expressing our true thoughts and feelings whether we wish them to or not. But what about disembodied eyes, which are the focal point of these three unusual sculptures? Louise Bourgeois was concerned with how our eyes can reveal thoughts and feelings best left unsaid, especially during the course of male/female relationships. Tony Oursler used his own eyes and mouth in *Junk*, which tends to attract visitors from all over the

**1**
**LOUISE BOURGEOIS**
(American, born France, 1911–2010). *Nature Study (Pink Eyes)*, 1984. Marble, steel, and wood, 20 x 45½ x 31½ inches (50.8 x 115.6 x 80 cm). George B. and Jenny R. Mathews Fund, 1984. Art © Louise Bourgeois Trust/Licensed by VAGA, New York, NY.

**2**
**TONY OURSLER**
(American, born 1957). *Junk*, 2003. Fiberglass sculpture and DVD projection, 29 x 39 x 16 inches (73.7 x 99.1 x 40.6 cm). Sarah Norton Goodyear Fund, 2003.

**3**
**ERIKA WANENMACHER**
(American, born 1955). *Of the Beasts*, 2007. Wood, glass taxidermy eyes, paint, and steel, 68 x 18 x 18 inches (172.7 x 45.7 x 45.7 cm). Gift of A. Conger Goodyear, by exchange, 2010.

1

Gallery with its sound before captivating them further with its unexpected and unusual appearance. People often listen for quite a while before realizing that the script is not coherent—it combines everyday words, random statements, and thoughts that might go through someone's head but are not normally expressed aloud. The taxidermy eyes and glow-in-the-dark constellations covering the carved wood self-portrait of Wicca practitioner Erika Wanenmacher express a feeling of oneness with the earth, its creatures, and the universe.

2

3

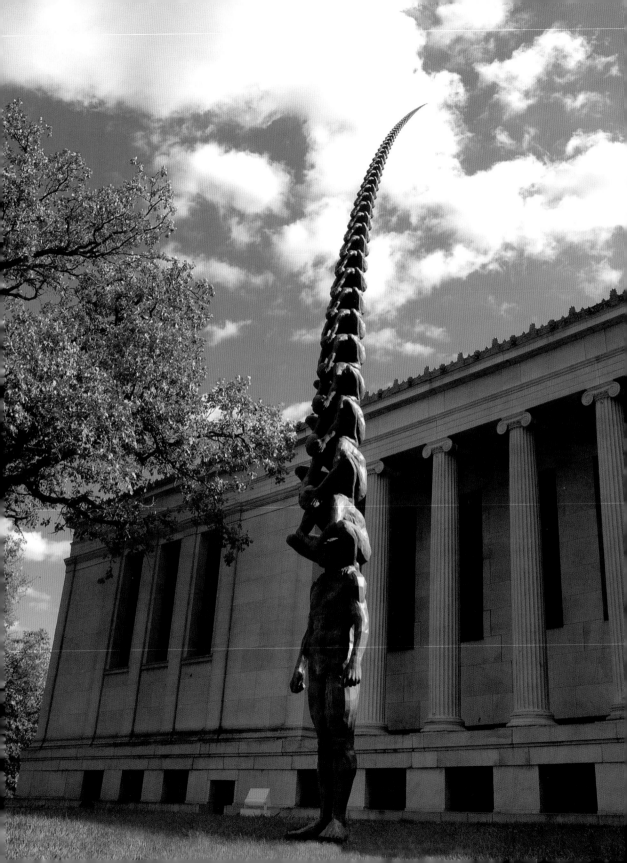

# A SENSE OF BELONGING

Human beings, with our inherent need to belong, are drawn to individuals with similar backgrounds, interests, values, and beliefs. Family is a cornerstone for many people, and artists throughout the centuries have represented family relationships in a variety of ways. Other artists approach issues of group identity through concepts like race, religion, or even the overarching idea that, in spite of our differences, we as human beings are all inherently connected. Diverse individuals are also often united through common activities, such as catching the perfect wave, singing a song, or cheering for a favorite sports team.

**DO HO SUH**
(Korean, born 1962).
*Karma*, 2010. Bronze,
edition 1/3, 276 inches
(701 cm) high. Bequest
of Arthur B. Michael, by
exchange, 2010.

The base of Do Ho Suh's *Karma* is a strong, standing figure. On his shoulders crouches the first in a series of identical figures, each slightly smaller than the one below. The figures rise twenty-three feet in the air and curve back in an impressive defiance of gravity. On one level, the title and composition reflect the traditional Buddhist and Hindu notion of karma, which holds that the consequences of a person's actions in this life will affect his or her experience in the next one. On another level, the sculpture might evoke generations—of humanity overall, or of individual families—and how we are all the product of our forebears, even if memories of them are as distant as the tiny figures at the top of the arc. The work also suggests the idea of connection and how we depend on one another for community and survival. Each figure covers the eyes of the one below, which may refer to the importance of trust—if only one figure were to move, the entire structure would come tumbling down.

In *Inhabit*, Janine Antoni explores her role as the mother of a young daughter. Antoni's original concept for this work developed from her idea of a spider weaving a web between her legs. She has explained, "I equated the spider and its web with my daughter, and myself, the mother, with the support structure." After consulting entomologists and realizing that her idea was impossible, Antoni devised this complex composition, in which she hangs in a harness in her daughter's bedroom, holding open the doors of a dollhouse that surrounds her legs. She has said of the work, "I intentionally create an ambiguous image that reflects the complex reality of motherhood. . . . The elastic scale-shifting in the photograph acknowledges the mother's required flexibility. She's a ubiquitous presence, and yet her role requires a degree of withdrawal. A mother has to clear space for the development of the child's imagination . . . [,] to be a point of stillness whose function is to nurture. In *Inhabit* I depict myself as half–hermit crab, because I'm carrying my house on my body, and half-spider, because I'm still at the center of the converging ropes. . . . In the end, the substitution of the house for the skirt allows the mother to wear the family drama."[1]

**JANINE ANTONI**
(Bahamian, born 1964).
*Inhabit*, 2009. Digital print,
edition 2/3, 116½ x 72
inches (295.9 x 182.9 cm).
Charles Clifton Fund, 2010.

In Paul Pfeiffer's work *Caryatid*, the artist has captured a crowd of strangers and a close-knit group of athletes all sharing the same moment of joy. The scene is one any hockey fan will recognize—a team that has won the Stanley Cup exuberantly passes it around to allow every player the opportunity to live out the dream of a lifetime: raising the Cup in victory. But in Pfeiffer's video, the winning athletes are seemingly invisible, as the prize floats around the arena on its own to the wild cheering of the crowd. Upon very close observation, however, we can glimpse traces of the players—a shadow here, a reflection there, a ghostly shape as they skate by other figures or objects. Speaking of his "erasure" of the participants, Pfeiffer has pointed out, "What was going on was not so much erasure. . . . It's actually more like camouflage."[2] The computer manipulation turns the Stanley Cup into an almost spiritual object of desire—the Holy Grail of the sport—every player seeks it, and every fan wants to be present when his or her favorite team fulfills its quest to capture it.

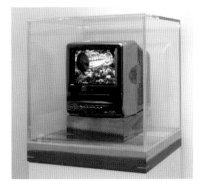

**PAUL PFEIFFER**
(American, born 1966).
Detail (top) and installation view of *Caryatid,* 2003.
Digital video loop, chromed nine-inch color television, and DVD player, Plexiglas case on pedestal, 56 x 20 x 20 inches (142.2 x 51 x 51 cm). Sherman S. Jewett Fund, by exchange and Gift of Dennis and Debra Scholl, 2010.

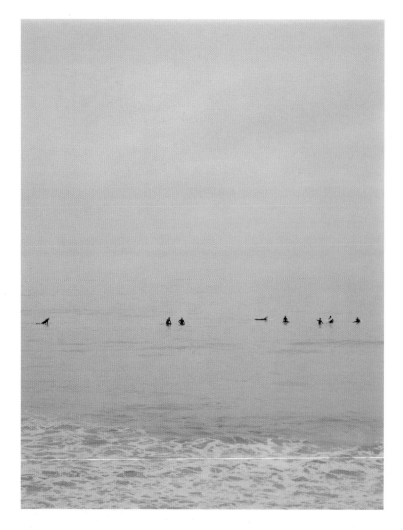

**CATHERINE OPIE**
(American, born 1961).
*Untitled #9* from the series
"Surfers," 2002–03. Color
print, edition 5/5,
50 x 40 inches (127 x 101.6
cm). George B. and Jenny
R. Mathews Fund, 2004.

For her series "Surfers," Catherine Opie photographed people she does not know, living a life she has not experienced—the surfing community in Malibu, California. Rather than photographing them riding dramatic waves, she captured the surfers doing what they do most of the time—wait. One of her main attractions to surfing is the fact that when individuals are out on their boards they are transformed into a community that goes beyond race, religion, and social status. Opie has stated, "You could be a high-powered lawyer or the stoner that lives in his van, it no longer matters. In that time and place is a moment of community that goes beyond the economy of the city."[3] Another important aspect of the "Surfers" series is the contemplative atmosphere, which allows us to picture ourselves next to the artist on the beach and imagine the sound of waves breaking gently on the shore, the cries of seagulls, and perhaps even the surfers' conversations carrying over the water.

In the series "Album," Gillian Wearing considers her identity in the context of family. After selecting photographs from her own family's album, Wearing enlisted designers, sculptors, and stylists to help her transform herself into various family members using wigs, masks, and even bodysuits. The Gallery's Collection includes six works in the "Album" series: Wearing as her father, her mother, her uncle, her brother, her sister, and herself as a teenager (illustrated here). The eyes are all that remain visible of the adult Wearing. She has explained, "I was interested in the idea of being genetically connected to someone but being very different. There is something of me, literally, in all those people—we are connected, but we are each very different."[4] Wearing is also intrigued in general by family albums, which by their nature can reach only so far into the past, but can extend infinitely into the future, meaning that at some point families will be able to look back at hundreds of years of ancestors.

**GILLIAN WEARING**
(British, born 1963). *Self Portrait at 17 years old* from the series "Album," 2003. Digital color print, edition 4/6, 45½ x 36¼ inches (115.6 x 92.1 cm). Charles Clifton Fund, 2004.

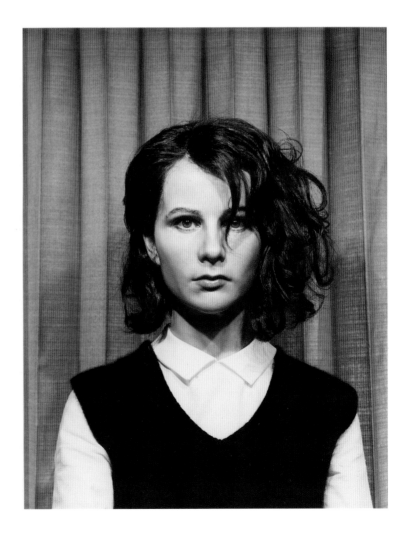

In her "Colored People" series, Carrie Mae Weems explores and celebrates the diversity of African American skin tones and the language used to describe them within the community. She recalled, "When I was a kid I was called 'Red Bone' . . . . And so that idea about being a 'red girl' as opposed to a 'carmel-colored girl' or a 'chocolate-colored girl' I thought was really sort of fabulous in a way of really being very specific about what somebody looked like, what their color reflected." Weems photographed children for this series, because she believes that issues related to color first arise during childhood, and that boys and girls should be helped to affirm their identity. The colored filters she used remind us that we see everything through the filters that result from our upbringing and experience. She has commented, "I started toning them . . . [in] all those different colors . . . in the hopes of really stretching the idea beyond the sort of narrow confines of race as we know it in the United States and starting to really play out a much brighter idea about both the sort of absurdity of color and also the beauty and the poignancy of color as well."[5]

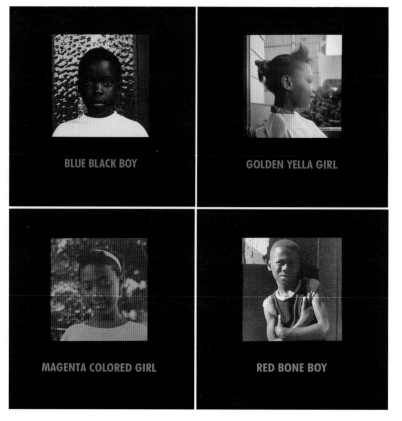

BLUE BLACK BOY

GOLDEN YELLA GIRL

MAGENTA COLORED GIRL

RED BONE BOY

**CARRIE MAE WEEMS** (American, born 1953). "Colored People" series, 1997. *Blue Black Boy*, edition AP 1/2; *Golden Yella Girl*, edition 2/5; *Magenta Colored Girl*, edition AP 1/5; *Red Bone Boy*, edition 1/5. Toned and/or color-stained silver prints with text on mat, 30 x 30 inches (76.2 x 76.2 cm) each. Gift of Seymour H. Knox, Jr., by exchange, 2008.

**BYRON KIM**
(American, born 1961).
*Synecdoche*, 2008. Oil and
wax on wood, 10 x 8 inches
(25.4 x 20.3 cm) each.
Bequest of Arthur B.
Michael, by exchange, 2008.

Since 1993, Byron Kim has re-created hundreds of people's skin tones on small, identically sized panels that have been exhibited in groups of various sizes in a number of American museums. The composite version of this work, arranged alphabetically by first name and now consisting of more than four hundred panels, was recently added to the collection of the National Gallery of Art in Washington, D.C. The title, *Synecdoche*, is a grammatical term meaning "a part standing in for the whole," such as *a set of wheels* to mean "car." Kim has noted, "Every part of [*Synecdoche*] represents the whole. . . . And the whole piece represents all of us in a way."[6] With the Gallery's 2008 commission that resulted in this work, the thirty-six members of The Buffalo Fine Arts Academy's Board of Directors became part of Kim's project. The artist created two versions of each panel; one for the Albright-Knox's Collection and one to incorporate into the National Gallery's piece. The fact that it is difficult to accurately define the racial composition of the BFAA Board brings up just one of the many levels of meaning underlying Kim's important and thought-provoking project.

The biblical parable of the Return of the Prodigal Son is the tale of two brothers, each of whom receives a share of his father's estate. One son stays home and helps his father, while the other leaves home and squanders his share by living irresponsibly. When he returns home, penniless but repentant, his father's open-armed welcome serves as a lesson in forgiveness and family love. Romare Bearden updated the story: "The Prodigal Son has left North Carolina, gotten into bad company and has come back to the 'old folks,' his home, where, as Robert Frost says, when no one else wants you, <u>they</u> got to take you in."[7] In Bearden's version, the returning son is greeted by two women, perhaps his mother and grandmother. The candle between them might be the proverbial candle in the window, left burning as a token of love and welcome for returning family members. Both versions of the story offer the possibility of starting over, with family as a source of support, stability, and love.

**ROMARE BEARDEN**
(American, 1911–1988). *Return of the Prodigal Son*, 1967. Mixed media and collage on canvas, 50 x 60 inches (127 x 152.4 cm). Gift of Mr. and Mrs. Armand J. Castellani, 1981. Art © Romare Bearden Foundation/Licensed by VAGA, New York, NY.

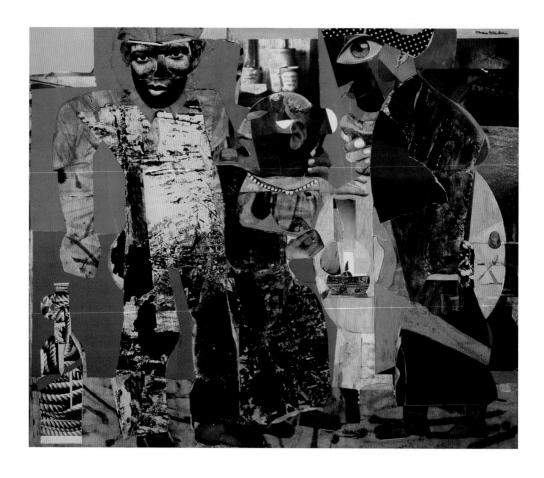

**PHIL COLLINS** (British, born 1970). *the world won't listen,* 2004–07. Synchronized three-channel color video projection with sound, edition 3/3. Running time: 57 minutes. Owned jointly by Albright-Knox Art Gallery, Buffalo; Charlotte A. Watson Fund, by exchange and Carnegie Museum of Art, Pittsburgh; The Henry L. Hillman Fund, 2008. Top to bottom: *el mundo no escuchará,* 2004; *dünya dinlemîyor,* 2005; *dunia tak akan mendengar,* 2007.

This work, which features a variety of people in three countries singing karaoke versions of songs from The Smiths' 1987 album *The World Won't Listen,* was years in the making. Phil Collins began in Bogotá, Colombia, where he worked with local musicians to create the background music and build a karaoke machine. He recruited performers through media appearances and invitations posted throughout the city. The second segment was recorded in 2005 in Istanbul, Turkey, and the final component in Jakarta and Bandung, Indonesia. The backdrops—including a desert, a field, a lake surrounded by trees, and a sunset—unify the clips, along with the music. *the world won't listen* not only reflects the way popular culture can connect people in distant parts of the world, but also highlights human beings' shared characteristics, which are often hidden behind political, religious, and other differences. Music, like art, is a universal language, and as viewers of this work, we share the experiences of Collins's performers as we laugh, cry, dance, or even sing along.

Walking was the first mode of human transportation. Although still a common way to get from one place to another, today it also has other connotations, such as leisure time, fitness, and collecting money for various causes. In *Chemin de halage à Argenteuil (Tow-Path at Argenteuil)*, Claude Monet's goal was to represent the atmosphere of a late winter day in the Paris suburb where he lived and to allow us to experience what the man on the path might be feeling as he pauses on his walk to look out across the river. Julian Opie's man and woman walk

1

2

continuously, alternately taking the lead. The original source for the work was a video of two people walking on treadmills, which the artist then animated and simplified. *Julian and Suzanne Walking*, with its rhythm and continuity, inspires discussion on a surprising number of levels and frequently transfixes visitors of all ages. Walking is the most important component of Richard Long's art, and his projects have taken him to every continent except Antarctica. Because museum visitors cannot accompany him, he creates evocations of his experiences in works like *Santa Cruz Circle*, which recalls a walk in the Argentine state of Santa Cruz, located in the remote southern region of South America called Patagonia.

**1**
**CLAUDE MONET**
(French, 1840–1926).
*Chemin de halage à Argenteuil (Tow-Path at Argenteuil)*, ca. 1875.
Oil on canvas, 23⅝ x 39⅜ inches (60 x 100 cm). Gift of Charles Clifton, 1919.

**2**
**JULIAN OPIE**
(British, born 1958). *Julian and Suzanne Walking*, 2007. Computer film and LCD screen, edition 3/4, 43⅜ x 51¾ x 4½ inches (109.9 x 131.5 x 11.4 cm). Bequest of Arthur B. Michael, by exchange, 2008.

**3**
**RICHARD LONG**
(British, born 1945). *Santa Cruz Circle*, 1997. Slate, 132 inches (335.3 cm) diameter. James S. Ely and Elisabeth H. Gates Funds, by exchange, 1997.

**3**

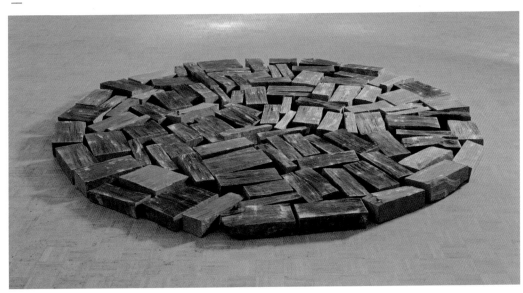

# IT TAKES ALL KINDS

Before the development of photography in the nineteenth century, a person's likeness could be recorded only by drawn, sculpted, or painted portraits, which were available only to the wealthy. The best portrait painters captured character and personality in addition to physical appearance and often included objects that reflected their subjects' lives and interests. Once photography could achieve these documentary goals, many artists began to explore new ways to represent, utilize, and interpret the human figure—and to create characters of their own.

**RINEKE DIJKSTRA**
(Dutch, born 1959).
*Coney Island, N.Y.,*
*USA, June 20, 1993,*
1993; printed 1998.
Color print (unique),
62⅝ x 50¾ inches
(159.1 x 128.9 cm).
Purchased in Memory
of Bernard D. Welt,
Barbara D. Bernheim
and Ida Z. Welt, 2004.

Rineke Dijkstra's "Beach Portraits" feature adolescent boys and girls from countries including The Netherlands, Gabon, the Ukraine, and the United States. The artist placed each child alone against the vastness of the ocean and photographed him or her straight on, in a pose of the child's choice. Dijkstra often captured the moment just before her model reached a pose or just after she or he released it. One of the artist's main goals is to make the everyday appear special, and in *Coney Island, N.Y., USA*, she managed to capture not only the hesitance, insecurity, and awkwardness of the young girl, but also her inherent beauty and dignity, characteristics shared by adolescents around the world, as the multinational "Beach Portraits" confirm. This image fits the characteristics Dijkstra described when asked what makes one photograph stand out from another: "A photograph works best when the formal aspects such as light, colour and composition, as well as the informal aspects like someone's gaze or gesture come together. In my pictures I also look for a sense of stillness and serenity. I like it when everything is reduced to its essence. You try to get things to reach a climax. A moment of truth."[1]

Chuck Close begins many of his images with enlarged photographs of friends. *Janet* depicts the artist Janet Fish, who arrived at the artist's studio with two pairs of glasses and two pairs of earrings, to allow Close some choice. He selected the more distinctive of each. After covering both the photograph and a canvas of identical size with grids, he began in the upper left-hand corner and moved across row by row, transferring the image square by square. However, rather than replicating the photograph exactly, he re-created the image by turning each square into a miniature abstract composition. When observed up close, the entire painting is completely abstract; only from a distance does Janet emerge as a coherent figure. What did Fish think of her friend's efforts? She was thrilled at the way Close captured "a sparkle that I liked, a jump, and the way things moved very fast."[2]

OPPOSITE:
**CHUCK CLOSE**
(American, born 1940).
*Janet*, 1992. Oil on
canvas, 100 x 84 inches
(254 x 213.4 cm). George
B. and Jenny R. Mathews
Fund, 1992.

**JACQUES-LOUIS DAVID**
(French, 1748–1825).
*Portrait of Jacques-François
Desmaisons*, 1782. Oil on
canvas, 36 x 28½ inches
(91.4 x 72.4 cm). General
Purchase Funds, 1944.

After nine-year-old Jacques-Louis David's father was killed in a duel, his
uncle, Jacques-François Desmaisons, helped David's mother raise him.
Desmaisons was a prominent architect—a member of the Royal Acad-
emy of Architecture and architect to French King Louis XVI. Here he is
pictured with the tools of his profession, a plan he is in the process of
designing, and books about architecture, including one by the sixteenth-
century Italian architect Andrea Palladio, whose work was popular in
France at the time. Desmaisons's station in life is also expressed through
his fashionable attire, which includes an embroidered yellow satin vest, a
coat with gold braid and fur trim, and a powdered wig. The artist added
a bit of personality as well, making it appear as if his uncle has paused in
his work to acknowledge our presence.

**THOMAS RUFF**
(German, born 1958).
*Portrait (R. Eisch)*, 1999.
Color print, edition 4/4,
82⅜ x 65 inches (209.9
x 165.1 cm). Sarah Norton
Goodyear Fund, 2001.

Unlike many artists, Thomas Ruff does not believe it is possible for a
photograph to express anything more than the surface appearance of
an individual. In his series of enlarged photographic portraits of friends,
such as *Portrait (R. Eisch)*, the figures are just objects—each presented in
a frontal pose on a neutral background and illuminated by a flash that cre-
ates a bright, impersonal light. The images are successful because Ruff's
subjects knew what the artist expected and acted accordingly, keeping
their faces as free of expression as possible. The attempts of critics and
viewers to read meaning where none was intended once led Ruff to
comment, "Why can people not just go and look at them and say: Aha,
a large photo, a large head? Why can't they just accept the picture as a
picture and say: 'Thank you Mr. Ruff, you did that well?'"[3]

In 1911, Ernst Barlach stated, "My mother tongue is the human body . . . the object through which or in which man lives, suffers, enjoys himself, feels, thinks."[4] Unlike many sculptors of his time, Barlach believed that a clothed body was more revealing than an unclothed figure, and he used the garments to help express his themes. *The Avenger* represents the artist's response to the outbreak of World War I, which was initially one of relative enthusiasm. The concept of "avenger" is conveyed simply, yet extremely effectively. The force of the man's forward movement is emphasized through the work's horizontal orientation, its slanted base, and the way the cloak flows back against the figure in diagonal folds. He carries a weapon that can only be used in hand-to-hand combat, and raises it to strike with a gesture that is at the same time heroic and tragic. His facial expression is difficult to define, reflecting the ambiguous nature of war, which, whether or not it is thought to be justified, is always horrific. Thus the sculpture presents not only the physical experience of war, but the psychological conflict as well.

**ERNST BARLACH**
(German, 1870–1938). *Der Rächer (The Avenger),* 1914. Bronze, 17 x 22⅞ x 8¾ inches (43.2 x 58.1 x 22.2 cm). Charles Clifton Fund, 1961.

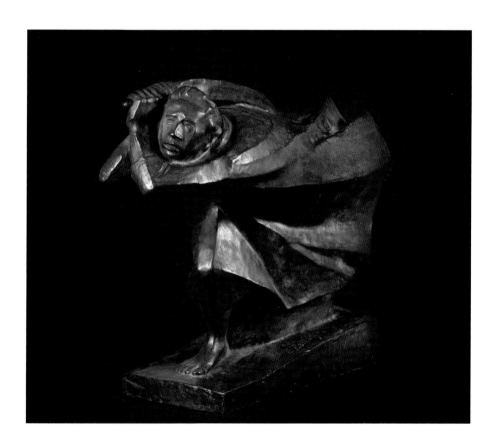

For his series of DNA portraits in triptych form entitled "The Garden of Delights," Iñigo Manglano-Ovalle selected sixteen people as his subjects. He then asked each of them to choose two additional individuals to be part of his or her triptych and to select the primary color that would make up the image. One of Manglano-Ovalle's references for this body of work was the tradition of Spanish *casta* (caste) paintings, created in the seventeenth and eighteenth centuries to categorize sixteen potential mixes among the three major ethnic groups (Spanish, African, and Native American) in Spain's American colonies. These paintings, with titles such as *Spaniard with Black Makes Mulatto*, each depict a man and woman of differing ethnicities along with their child. Although "The Garden of Delights" may evoke the science of DNA and its implications for our genetic future, Manglano-Ovalle has stated that the series "was not a response to the new technology of genetics. It was not about visualizing science. It was because all of a sudden (we had just had the O. J. Simpson trial in 1994) the DNA fingerprint was a new image. What really fascinated me was that abstract image and the idea that we, the public, incorporated it into our vocabulary and our understanding of image and of abstraction."[5]

**IÑIGO MANGLANO-OVALLE** (American, born Spain, 1961). *Doug, Joe and Genevieve* from "The Garden of Delights," 1998. Set of three color prints, edition 3/3, 60 x 74 inches (152.4 x 188 cm). Charles Clifton Fund, 2001. Image courtesy Donald Young Gallery, Chicago.

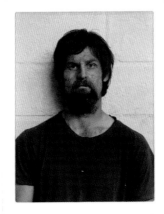
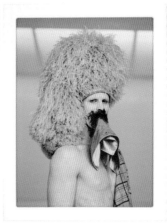

**MATTHEW BARNEY**
(American, born 1967).
*Cremaster Suite*, 1994–2002.
Set of five color prints
with self-lubricating plastic
frames, edition 10/10,
44 x 34 inches (111.8 x 86.4
cm) each. Sarah Norton
Goodyear Fund, 2003.

These photographs represent characters from Matthew Barney's best-known project, a series of five films titled the "Cremaster Suite," 1994–2002, which exemplifies the artist's wide-ranging and multilayered approach. The entertainer Marti Domination, as the character Goodyear in *Cremaster I*, sits under tables in each of two Goodyear blimps that hover over a stadium in Boise, Idaho (the artist's hometown), and uses grapes to make patterns that are echoed by dancing girls on the fields below (top left). *Cremaster II*, in the style of a Gothic western, focuses on the life and execution of Gary Gilmore, played by Barney (top middle). *Cremaster III* tells the story of the construction of the Chrysler Building in New York City, with Barney in the role of the Entered Apprentice, who is depicted working on the building (top right). The fourth film is set on the Isle of Man, and involves both the folklore of the island and its contemporary role as host to the Tourist Trophy motorcycle race. In this story of two racers, Barney appears as the Loughton Candidate, a satyr with sockets in his head that eventually grow into the horns of the Loughton Ram, an ancient breed native to the island (bottom left). The actress Ursula Andress stars as the Queen of Chain in *Cremaster V*, a tragic love story set in nineteenth-century Budapest (bottom right).

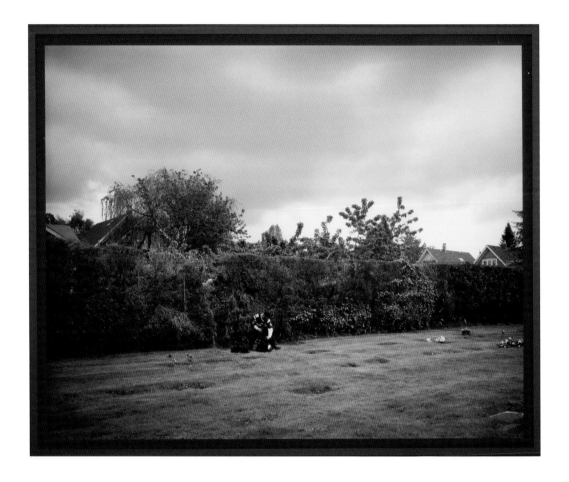

**JEFF WALL**
(Canadian, born 1946).
*Boys cutting through a
hedge, Vancouver,* 2003.
Transparency and light box,
edition 1/2, 87¾ x 109¾ x
10⅜ inches (222.9 x 278.8 x
26.4 cm). Gift of Seymour H.
Knox, Jr. and the Stevenson
Family, by exchange, 2004.

Jeff Wall never wanted to be a traditional photographer—one who was
constantly in search of the perfect image only to have it reproduced on
a relatively small scale. Impressed by large-scale paintings that immedi-
ately engage viewers through their size, Wall decided, "If painting can
be that scale and be effective, then a photograph ought to be effective
at that size, too." His works are inspired by incidents he sees in the real
world—in the case of the Gallery's work, two boys cutting through a
hedge. After thinking about the events he has witnessed, Wall selects
those he wants to photograph and hires models to reenact them. After
creating the large pictures he calls "cinematographic photography," he
places them in large light boxes like those used in advertising. Once
the light captures our attention and draws us in, the detail in the image
engages us. Wall has commented, "It has a semblance of life occurring
on the fly, but it is a semblance. A semblance has its own value."[6]

Justine Kurland spends a lot of time on the road searching for her photographic subjects. This image is from a series called "Golden Dawn," which explores thirteen back-to-the-land communes she visited over six months. The term *Golden Dawn* may refer to the idealism of these groups, who strive to escape the industrialism and consumerism of modern society by supporting themselves in an environmentally responsible way in nature. Kurland spent time getting to know the commune members, immersing herself in their lifestyle. She asked them to pose nude to parallel their back-to-nature philosophy. Kurland's only instruction to her models is where to stand, sit, or walk—the rest is up to them. The two girls in this work wrapped themselves in duvets to protect themselves from the cold while posing with two old school buses. The artist has commented that this combination of planning and chance allows for "the tension that lies between the staging and the unpredictability."[7]

**JUSTINE KURLAND**
(American, born 1969).
*Buses on the Farm*, 2003.
Color print, edition AP1,
17¾ x 22½ inches
(45.1 x 57.2 cm). Sherman
S. Jewett Fund, Kirchofer
Trust and Irene Pirson
Macdonald Fund, 2010.

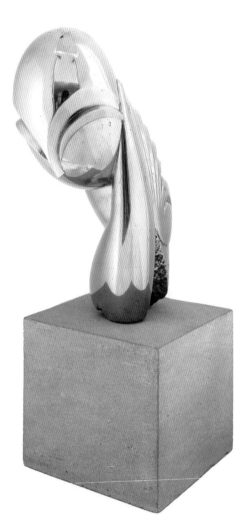

**CONSTANTIN BRANCUSI**
(French, born Romania,
1876–1957). *Mademoiselle
Pogany II*, 1920. Polished
bronze: 17¼ x 7 x 10 inches
(43.8 x 17.8 x 25.4 cm),
on base: 7 x 8½ x 9 inches
(17.8 x 21.6 x 22.9 cm).
Charlotte A. Watson
Fund, 1927.

Constantin Brancusi met the Hungarian painter Margit Pogany in 1910. After visiting his studio, she asked Brancusi to create her portrait. She sat for him several times, during which he made clay studies and sketches; after she returned to Hungary, Brancusi carved her portrait in marble from memory. Three versions of *Mademoiselle Pogany* exist, each of which was created in both marble and bronze. The first was completed in 1913, when Brancusi wrote to ask which medium Mademoiselle Pogany would prefer. She asked him to decide, and she received a bronze version, along with instructions to avoid putting fingerprints on the surface. The Gallery's *Mademoiselle Pogany II*, the first Brancusi sculpture to be acquired by a museum,[8] is more abstract than the first. The eyes, which the artist felt were the young woman's most distinguishing feature, are extremely large. The arms blend together in one graceful movement upwards, and abstract spirals reminiscent of hair cascade down her neck. In 1931, Brancusi created a third, even more abstracted version, stating, "Perhaps I may think of still a better interpretation some day. Who can ever say that a work of art is finished?"[9]

Throughout his career, Jean Dubuffet searched for things that were new. With lines, colors, and forms like those seen here, which he named *Hourloupe*, Dubuffet felt that he had finally created an original and alternative world that encompassed all facets of the visual arts. The culmination of Dubuffet's "Hourloupe Cycle" was a series of installation/performances he called *Coucou Bazar*, the first of which took place at New York's Guggenheim Museum in 1972. Actors wore costumes that looked like *Le Vociférant (The Loud One)* and moved almost imperceptibly through fantastic Hourloupe settings. The visual spectacle was accompanied by a musical score that included large booms, mumbled voices, and intermittent periods of silence. The experience was intended to place viewers in a new reality separate from our world, complete with its own time reference, scale, inhabitants, and sound. Dubuffet designed the original costumes by drawing on stiffened paper reinforced with wire. After cutting out the drawings, he spontaneously assembled them to create the costumes, without any preconceived idea of how the pieces would ultimately come together. *Le Vociférant (The Loud One)* is one of a number of sculptures that reproduce the costumes in painted sheet metal.

**JEAN DUBUFFET**
(French, 1901–1985). *Le Vociférant (The Loud One)*, 1973. Painted sheet metal, 88 x 58½ x 34 inches (223.5 x 148.6 x 86.4 cm). Gift of Seymour H. Knox, Jr., 1973.

## CUT IT OUT

Each of these artists began with a different source for his or her elegant, cut images. Arturo Herrera created his untitled work through a time-consuming process of cutting large sheets of painted paper into complex and delicate patterns. Details borrowed from a Snow White and the Seven Dwarfs coloring book—hats, shoes, and even fragments of Snow White herself—are mingled with a tangled web of green lines suggesting an imaginary landscape. Soo Kim's work began with a photograph, the back of which was covered with metallic paint. She added a third dimension

**1**
**ARTURO HERRERA**
(Venezuelan, born 1959).
*Untitled*, 2003. Paint on
paper, 65 x 205 inches
(165.1 x 520.7 cm).
Sarah Norton Goodyear
Fund, 2003.

**2**
**SOO KIM**
(South Korean, born 1969).
(*A long pause*), 2010.
Acrylic paint on hand-cut
chromogenic print, 50 x 50
inches (127 x 127 cm).
Pending Acquisition Funds,
2011.

**3**
**MARK FOX**
(American, born 1963).
*Untitled (Fault)*, 2008. Ink on
paper, linen tape, and metal
pins, 50 x 131 x 11 inches
(127 x 332.7 x 27.9 cm).
Elisabeth H. Gates, James
G. Forsyth and Edmund
Hayes Funds, 2009.

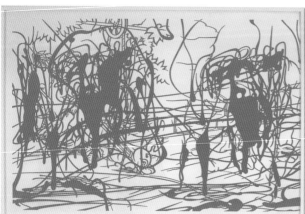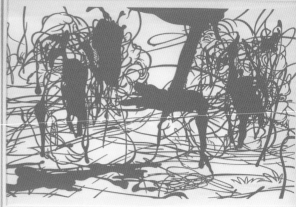

1

to the work by cutting out some of the forms in the photograph and allowing them to cascade down, revealing the metallic paint for added effect. The work's title is a stage direction from Jean Genet's play *The Balcony*—Kim sees a parallel between this important, yet silent, part of the play and the elements she has cut from her photographs. Mark Fox copied various mythological and religious texts by hand, then cut them into intricate patterns that are pinned to the wall in compositions that gently move with the air currents. He has commented, "By taking a razor to these transcribed doctrines, I am seeking to examine the edges of these dogmas; to scrutinize the ways in which their meaning and implications underpin contemporary culture."[1]

2

3

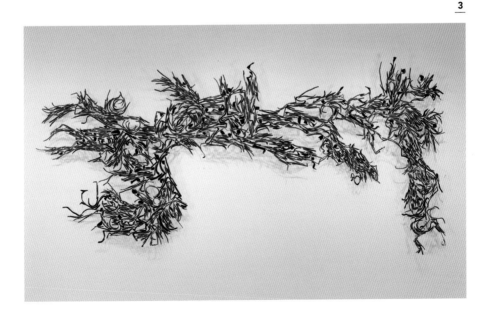

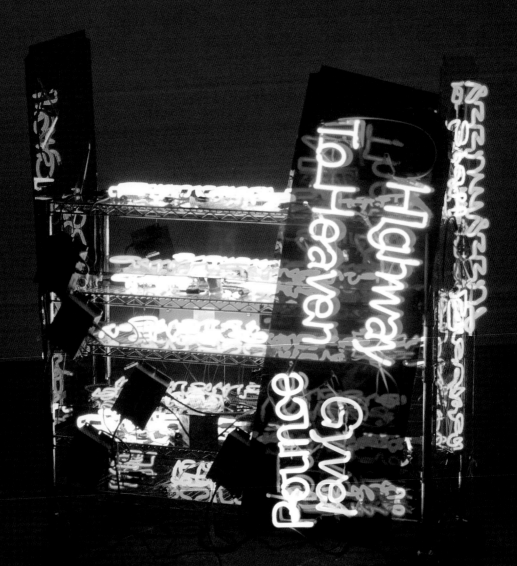

# A COMMON LANGUAGE

Whether or not a picture is worth a thousand words depends on the picture, the words, and what the creator is trying to convey. Each means of expression has distinct advantages and disadvantages, and their interrelation takes many forms. For example, some things that can be described eloquently in words cannot be easily represented visually. On the other hand, a picture can often be more effective than ten thousand words. Context is extremely important, as is the life experience of the reader or viewer. Combinations of images and words are very common in daily life: many books are illustrated, most photographs in the news media are accompanied by either full stories or captions, and visual artists since the early decades of the twentieth century have found numerous creative ways to incorporate words into works in all media.

**JASON RHOADES**
(American, 1965–2006).
*Highway to Heaven*, 2003.
Neon glass, Plexiglas,
neon transformers, metal
shelving, ceramic donkeys,
aluminum blocks, neon
GTO cable, 10-outlet surge
suppressor, rubber end
caps, metal hooks, and
orange extension cord,
52 x 20 x 41 inches
(132.1 x 50.8 x 104.1 cm).
Sarah Norton Goodyear
Fund, 2009.

Jason Rhoades believed in combining art and life, and his complex installations often pose questions about contemporary society. *Highway to Heaven* evolved from a larger installation called *Meccatuna*, which dealt with issues relating to Islam, spirituality, commercialism, and the role and treatment of women. The title refers to the important Muslim pilgrimage to Mecca, as well as Rhoades's plan to take a bluefin tuna as a companion on his journey. The ceramic donkeys, which refer to the animals that pull the carts of street peddlers, evoke the commercialism that awaits pilgrims at many important religious sites. In the press release announcing Rhoades's exhibition of *Meccatuna* at the David Zwirner gallery, one of the numerous components of the installation was listed as "550 vagina euphemisms. Multicolored neon tubes mounted onto 227 translucent, colored Plexiglas panels with lace, elastic, and coated wire." A number of those neon tubes and Plexiglas panels featuring slang terms for female genitalia appear in *Highway to Heaven*. In *Meccatuna*, they served as an allusion to the role of women in the Islamic world; removed from that context, they suggest an expanded consideration of the treatment of women everywhere.

**LORNA SIMPSON**
(American, born 1960).
*Counting*, 1991. Photogra-
vure with silkscreen, edition
8/60, 73¾ x 38 inches
(187.3 x 96.5 cm). The
Gerald S. Elliott Fund, 1992.

Lorna Simpson's work addresses complex issues around the African American experience, especially that of women. The top image in *Counting* is of an anonymous woman wearing a plain white garment. The times to the right seem to indicate work shifts, but the schedules contain odd hours. The middle image presents a smokehouse in South Carolina that was once used as a slave hut. The accompanying numbers indicate that slavery was first acknowledged around 310 years before this work was created, and, presumably, that 1,575 bricks were used to construct the tiny building. Beneath the bottom image is an accounting of twists, braids, and locks, suggesting that the depicted hair represents the life of an old woman who has seen and experienced much. Simpson has said, "I would hate to think that my work is perceived as a portrayal of victimization. . . . I want to relate the dynamics of a situation . . . and how it affects people's lives. . . . It's inten-tionally left open-ended. There's not a resolution that just solves everything."[1] Viewers are left to draw their own conclusions and, the artist hopes, to learn something in the process.

**LESLEY DILL**
(American, born 1950).
*Divide Light #2*, 2002.
Chiri paper, glue,
thread, tea, and pins,
38 x 4½ x 3 inches
(96.5 x 11.4 x 7.6 cm).
George Cary Fund, 2003.
(Detail at left.) © Lesley Dill.
Image courtesy George
Adams Gallery.

Lesley Dill once said, "Language is the touchstone, the pivot point of all my work."[2] She is interested not only in the meaning of words, but also in their aesthetic nature—the way they look and the patterns they can form. Dill has cited the nineteenth-century American poet Emily Dickinson as one of her major inspirations, and she often incorporates Dickinson's words into her work. The title *Divide Light #2* comes from Dickinson's poem "Banish Air from Air," which begins, "Banish air from air, divide light if you dare." The small hand that holds the letters, which are stained with tea, is a cast of Dill's own hand. She has said about works like this, "I wanted to make hands that were naked hands . . . that were . . . raw, that were vulnerable, that were inside of the protection of our normal skin. . . . And the hands—and the work about threads—are very much about fingertip energy. I especially love and use the tips of my fingers."[3] Appropriately, it is from the fingertips that the threads in this work gracefully descend.

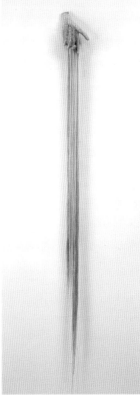

Glenn Ligon uses language in a variety of ways to consider the experience of being a gay African American man in today's society. His texts are often difficult to read, both physically and psychologically. The passage in this work was drawn from James Baldwin's essay "Stranger in the Village," written in 1953 when Baldwin was in Switzerland working on the novel that became *Go Tell It on the Mountain*. The essay discusses how Baldwin, who was an openly gay African American, felt like an outsider in the tiny Swiss village—the same way he felt in the United States before the Civil Rights Movement. The first line begins, "The rage of the disesteemed," and then disappears into the surface and becomes illegible. The fact that we cannot comprehend the important things being said alludes to how we are unable to understand how other people feel if we have not shared their experiences. As Ligon has said, "The paintings are fundamentally about language and an ambivalence and pessimism about the project of communicating, of going back and forth between really wanting to communicate with the viewer and also wanting to withhold things and the aggression of the withholding."[4]

**GLENN LIGON**
(American, born 1960). *Untitled (Rage) #2*, 2002. Mixed media on canvas, 74⅞ x 82⅝ inches (190.2 x 209.9 cm). Sarah Norton Goodyear Fund, 2002.

**HAMISH FULTON** (British, born 1946). *Touching By Hand One Hundred Rocks (Fifty Three, Fifty Four, Sixty)*, 1989. Black-and-white photographs, 46 x 54¼ inches (116.8 x 137.8 cm) each, framed. James G. Forsyth and Elisabeth H. Gates Funds, 1991.

Hamish Fulton's art takes its form as walks in the landscape; in the past two decades, he has covered more than twelve thousand miles on five continents. The photographs and texts he exhibits are created to share his experiences with others. These three photographs show a desolate yet compelling landscape with no signs of human presence. The text informs us that Fulton was on Hokkaido, the northernmost island of Japan, on a journey that involved seven days walking and seven nights camping. He made the trip in June 1989, and, at some point, saw a full moon. Another aspect of the walk is provided by the title: he touched one hundred rocks along the way. There are additional, subtler elements that reflect the location of his walk. Red is an auspicious color in many Asian countries and is often combined with black and white in Japanese art. The simple wood frames reflect many Japanese structures, and Fulton's signature—symbols surrounded by a circle—recalls those of the Japanese artists and poets who collaborated on combinations of landscape and language.

This piece, which at first appears as if it is leaning against the wall, waiting to be hung up by the Gallery's art preparators, offers visitors a view they are not accustomed to seeing—the back of a painting. In actuality, this work by Vik Muniz is a reproduction of the back (or *verso*) of the American artist Edward Hopper's famous painting *Nighthawks*, 1942, which is in the collection of The Art Institute of Chicago. The back of *Nighthawks* looks exactly like this—every scratch, dent, and mark has been painstakingly re-created by Muniz and a team of craftsmen, artists, and even forgers. He explained, "Whenever someone wants to see if an artwork is 'real,' the first gesture is to look at its back or at its base; the part of it that normally isn't visible to anyone but experts, dealers, museum conservators, or the artists themselves. This happens because while the image's objective is to remain eternally the same, its support is constantly changing, telling its story, showing its scars, its labels, and periodic clichés."[5]

**VIK MUNIZ**
(American, born Brazil, 1961). *Verso (Nighthawks)*, 2008. Mixed media, edition 1/3, 44⅛ x 70⅜ x 2⅛ inches (112 x 178.7 x 5.2 cm), with blocks. Charles W. Goodyear Fund, by exchange and George B. and Jenny R. Mathews Fund, by exchange, 2009. Art © Vik Muniz/Licensed by VAGA, New York, NY.

Although Tracey Emin has exhibited since the 1990s, it is only recently that her work, which incorporates a witty, blunt, and often humorous use of text, has captured wider attention. She has commented, "Part of the reason is because my work was always considered controversial. Now people are starting to see it as more establishment, so they're giving it more space. Also, you've got curators who are willing to stick their necks out because I'm of their generation. They don't see anything radical about what I do. They just see it as good art."[6] *Only God Knows I'm Good* was first seen in an exhibition of the same title at the Lehmann Maupin Gallery in New York in 2009, which explored themes characteristic of Emin's work, including love, lust, and sex. She has said, "I'm on a constant search for clarity. The title of the show . . . references David Bowie lyrics: 'God knows I'm good, God knows I'm good, surely God will look the other way today.' Life is complicated sometimes."[7]

**TRACEY EMIN**
(British, born 1963).
*Only God Knows I'm Good*, 2009. Snow white neon, edition 2/3, 25 x 136½ inches (63.5 x 346.7 cm). Pending Acquisition Funds, 2011.

**ED RUSCHA**
(American, born 1937).
*Electric*, 1963. Oil on
canvas, 72 x 67 inches
(182.9 x 170.2 cm).
Charles Clifton and
Edmund Hayes Funds,
1987.

Ed Ruscha's art has been informed by his life experiences. As a child,
he was impressed by film studio logos, which he felt "were almost as
memorable as the movies. That 20th Century Fox logo was indelible."
That logo later appeared in his work. When he decided he wanted to
become an artist, Ruscha considered several different avenues: "At first
I thought I wanted to get into advertising or some sort of design. Or
perhaps become a sign painter. It was all glamorous to me, the life of
an artist."[8] It is no surprise, then, that one of the major components
of his art is language, which he often combines with images that seem
unrelated. The Gallery's painting, however, provides a visual definition
of its single word. The background is "electric" blue, and the letters are
made up of vivid, warm colors that evoke heat and light. The use of
italics adds a note of excitement, energy, or tension reminiscent of
phrases such as "The room was electric!"

**NANCY DWYER**
(American, born 1954).
*Kill Yourself*, 1989.
Vinyl paint on canvas,
70 x 90 inches (177.8 x
228.6 cm). Gift of Olivia
Badrutt, 2008.

At first, this painting appears quite cheerful, with its cartoonish letters on a background of floating bubbles. What the letters spell out, however, severely challenges that initial impression. By using the visual language of advertising, Nancy Dwyer often creates this kind of contradiction between what you see and what it looks like. If we know that one of the initial inspirations for the painting was an ice cream shop window in Brooklyn, we might easily accept "Kill Yourself" as a harmless flavor of ice cream. However, if the original context for the words is unknown, as it is to the majority of viewers, the work can be somewhat disturbing. "Kill yourself" is not generally a socially acceptable thing to say, but comments like "You're going to kill yourself trying to get that finished in time" are essentially harmless. And where do the bubbles fit in? Dwyer is asking us to think about language, imagery, and meaning in new ways. As she has said, "I'm really satisfied with bringing you to a space in which to think about something, but not telling you what to think. People have to make their own valued conclusions about what they look at."[9]

Stefan Brüggemann's Text Pieces confront art-world traditions and more general aspects of contemporary society. A title such as *(NO CONTENT)*, with the words placed in parentheses, refers to the practice of naming a work *Untitled*. It also calls into question the notion of meaning in a work of art: for example, an object that offers this type of commentary cannot truly have, as it seems to imply, *no content*. The same question can be asked about language—can the words "no content" actually mean what they say? Brüggemann's work also serves as a critique of the current overemphasis on constant communication, in which the meaning and significance of a message are often diminished or lost entirely. In works like this, the artist challenges the very idea of meaning by stating its absence. The fact that this work is a light, and can be turned off, adds other layers of implication. Unsurprisingly, when Brüggemann was asked about meaning in his Text Pieces, he replied (in a play on Frank Stella's oft-quoted comment "What you see is what you see," itself a play on the phrase "What you see is what you get"), "The only thing that I could say about the Text Pieces is: what you read is what you get."[10]

**STEFAN BRÜGGEMANN** (Mexican, born 1975). *(NO CONTENT)*, 2004. Neon, 11½ x 75½ x 2¾ inches (29.2 x 191.8 x 6.9 cm). Purchased with funds provided by Marie and Fred Houston, 2008.

Francine Savard's long, thin paintings explore the relationships between color, language, and form. She begins each work by writing a text composed of the first lines of a novel. Then, she explains, "I associate words with colors . . . the same word in a different painting would be the same color." For words such as *you*, *of*, and *the*, Savard creates what she has called "a structure—things that are very solid, like blacks, and grays." In addition, she decided that "all the punctuation would be white, so people can recognize [it]."[11] She assigns colors from her distinctive palette to the rest of the words; the length of each color block relates to the length of the word or phrase it represents. Savard's translation of language into color is more complex than it first appears, as she considers both the French and English versions of each sentence. The quote used for this work is the first line of Georges Perec's novel *A Man Asleep*: "Dès que tu fermes les yeux, l'aventure du sommeil commence" ("As soon as you close your eyes, the adventure of sleep begins.")[12] Knowing that the comma is white and the words *you*, *your*, *the*, and *of* are black, the rest of the work is not difficult to "translate."

**FRANCINE SAVARD**
(Canadian, born 1954).
*A Man Asleep (Perec)*,
2010. Acrylic on canvas
mounted on fiberboard,
4 x 73 x 1½ inches
(10.2 x 185.4 x 3.8 cm).
Pending Acquisition
Funds, 2011.

Light has always been important to artists—whether they are representing natural light realistically, using it symbolically, or making abstract paintings that seem to glow. Jorge Pardo's installation of seven lamps transforms the museum space, not only with colored light but also with shadows. The reflections are such an integral part of the work that Pardo considers the lamps to be "present" only when they are switched on, implying that they essentially disappear when turned off. James Turrell once stated, "My material is light,

**1**

**JORGE PARDO**
(American, born Cuba, 1963). *Untitled (set of 7 hanging lamps)*, 2008. Glass and aluminum, dimensions variable. Sherman S. Jewett Fund, by exchange, Edmund Hayes Fund, 2009.

**2**

**JAMES TURRELL**
(American, born 1943). *Gap* from the series "Tiny Town," 2001/2006. Light installation, dimensions variable. General Purchase Funds, 2005.

**3**

**DAN FLAVIN**
(American, 1933–1996). *Untitled (to the citizens of the Swiss cantons) 1*, 1987. Red and daylight fluorescent light, edition 2/5, 48 inches (122 cm) on the diagonal. The Panza Collection and George B. and Jenny R. Mathews Fund, by exchange, George B. and Jenny R. Mathews Fund and Charles Clifton Fund, by exchange, 2008.

**1**

**2**

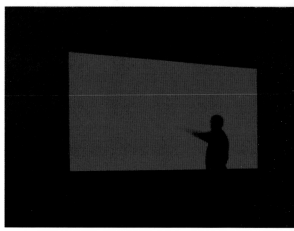

and it is responsive to your seeing."[1] After viewers feel their way through a pitch-dark passage and turn a corner, they enter *Gap* itself, where it takes a moment for their eyes to adapt to the semi-darkness. Eventually, a rectangle of purplish light takes shape on the opposite wall. Those who venture across the room will experience an unexpected surprise. Dan Flavin was one of the first to use physical light as an artistic medium. Due to the ethereal and mysterious moods his works evoke, he preferred the terms *proposal* and *situation* to *sculpture*. At times, he also referred to them as *icons* because of the parallels he saw between spaces illuminated with his work and the interiors of churches.

3

# CULTURAL COMMENTARY

All art is, on some level, a reflection of the time and place in which it is created. Some artists choose not to engage directly with controversial topics such as conflict, politics, gender, race, or the environment, but provide us with more neutral aspects of life to consider. Other artists make the decision to confront difficult issues head-on in an attempt to raise our awareness, encourage us to think, and perhaps even convince us to act to change society for the better.

**DORIS SALCEDO**
(Colombian, born 1958). *Untitled*, 1998. Wood, cement, and metal, 74 x 44 x 21½ inches (188 x 111.8 x 54.6 cm). Sarah Norton Goodyear Fund, 1999.

In her native country of Colombia, Doris Salcedo faces conflict that continually disrupts people's lives with disappearances, deaths, drug wars, and random acts of violence. Salcedo has witnessed some of this violence, both firsthand and through interviews with victims. In her sculpture, she attempts to communicate the Colombian people's plight through abstract, yet extremely expressive, means. The artist created numerous works like the one in the Gallery's Collection by reinforcing pieces of wood furniture with metal bars, then filling them with concrete that is smoothed by hand. The result is cold, heavy, and silent—for Salcedo, a parallel to the way many victims encase themselves in silence to help preserve both their lives and their psyches. The artist has commented, "My task as an artist is to make sense out of brutal facts. My work is an attempt to make violent reality intelligible. Needless to say, a lifetime is not enough for such a task. In the third world, we are well aware that human beings do not triumph over external reality. We must produce meaning out of the tensions and chaos generated by our harsh conditions. Making art is a way of understanding, a way of comprehending reality."[1]

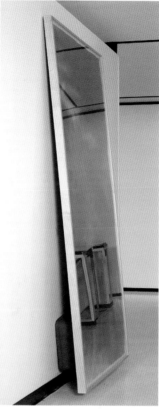

David Hammons's *Basketball Drawing* refers to the experience of African American youth, especially young men. Hammons created it using a basketball, bouncing it first in the dirt of Harlem and then on a piece of paper the exact height of a regulation basketball hoop. Basketball can have a contradictory impact on urban youth; while it creates a positive sense of community, it can also incite impractical hopes of a professional sports career, which can lead players to neglect education and other important aspects of life. Behind the drawing is a suitcase, which viewers only notice if they become curious about why the work is not hanging flush with the wall. This perhaps refers to the distance that is traveled, both physically and psychologically, between the courts of Harlem and the predominately white worlds of sports and of art, in which Hammons himself still often feels uncomfortable. Since "traveling" in basketball results in a penalty, perhaps it should be remembered that certain moves may have unexpected consequences.

**DAVID HAMMONS**
(American, born 1943).
*Basketball Drawing*, 2001.
Harlem earth on paper
and found suitcase,
116 x 46 x 12 inches
(294.6 x 116.8 x 30.5 cm).
George B. and Jenny R.
Mathews Fund, 2001.

With his well-known sink sculptures, which first appeared in the early 1980s, Robert Gober removes a familiar everyday household item from its expected context and alters it in ways that make its normal function impossible, forcing us to think about it differently. According to the artist, many of the objects that inspire him refer to transitions of some sort— in this case, from dirty to clean,[2] which could mean much more than simply physically washing your hands or face. For example, Gober's sinks are often considered surrogates for the human body in the context of gay identity and the AIDS crisis of the 1980s. While Gober is often willing to discuss his work, he frequently uses unrevealing titles because, as he has commented, at times he prefers "to hold back and not direct people."[3]

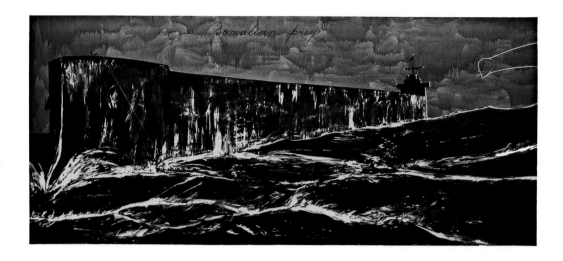

*Somalian prey*

José Bedia limits his use of color because, he has commented, "[It tends] to be distracting. I am interested in the content and in creating a work that is simple in its representation so that the content is palpable."[4] Because of its large scale and dramatic quality, *Somalian Prey* requires a few moments to fully comprehend. The front end of a huge ship plowing through a stormy sea dominates the left side of the work and extends into the distance, via a powerful diagonal, to the light-tipped control tower. The ship is so large that at first the Somali pirates in their tiny motorboat near the bow go unnoticed. One man who has already climbed the rope holds an automatic weapon as he waves his comrades aboard. It is hard to imagine the pirates' success against such a huge prey. The wind god on the right, who roils the waters with his breath, reflects the Cuban-born Bedia's interest in spiritual traditions that combine African, Native American, and Christian elements.

**JOSÉ BEDIA**
(Cuban, born 1959).
*Somalian Prey*, 2010.
Acrylic on canvas,
93¼ x 214⅜ inches
(236.9 x 544.5 cm).
Partial gift of Drs. Amy and
Julio Alvarez-Perez and
Charles W. Goodyear and
Mrs. Georgia M. G. Forman
Fund, by exchange, Gift of
A. Conger Goodyear, by
exchange, Elisabeth H. Gates
Fund, by exchange and
Sherman S. Jewett Fund,
by exchange, 2011

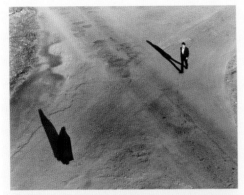

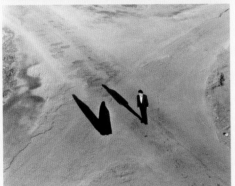

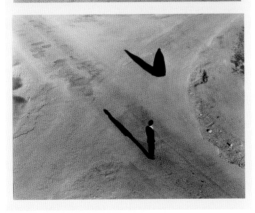

**SHIRIN NESHAT** (Iranian, born 1957). *Fervor (Couple at Intersection)*, 2000. Triptych of gelatin silver prints, edition 4/5, 49⅛ x 61⅝ inches (124.8 x 156.5 cm) each. Norman E. Boasberg Fund, 2000.

In 1974, Shirin Neshat came to the United States from Iran to attend college; she would not return home for twelve years due to the Islamic Revolution. The changes she encountered on her homecoming were overwhelming, leading her to explore the role of women in Islam through photography and video. These still images come from a video entitled *Fervor*, which follows a man and a woman through several settings. In the first encounter, they meet at a crossroads, seemingly in the middle of nowhere. The moment creates sexual tension, because even a gaze between a man and a woman is forbidden as a sin. In the video, it is clear that the woman pauses slightly, but does not look back, once she and the man pass, while the man boldly turns to watch her walk away. Nothing is simple about the situation. Neshat has said, "I see my work as a visual discourse on the subjects of feminism and contemporary Islam—a discourse that puts certain myths and realities to the test, claiming that they are far more complex than most of us have imagined. . . . I prefer raising questions as opposed to answering them as I am totally unable to do otherwise."[5]

**JAMES ROSENQUIST**
(American, born 1933).
*Nomad*, 1963. Oil on
canvas, plastic, and wood,
90⅛ x 140 x 25 inches
(228.9 x 355.6 x 63.5 cm).
Gift of Seymour H. Knox, Jr.,
1963. Art © James Rosen-
quist/Licensed by VAGA,
New York, NY.

*Nomad* reflects James Rosenquist's fascination with the way we are constantly bombarded by images, often making it difficult for us to focus. Perhaps the "nomad" in the title is our vision, which can find no focal point on which to rest. This work could, on one level, be interpreted as a summary of American society in the 1960s: people were barraged with commercial goods like Oxydol and spaghetti sauce; enjoyed more leisure time, represented by the ballet dancers, picnic table, and microphone; experienced the NEW; and had enough disposable income to take advantage of it all. The avid consumerism of the time may be reflected in the large scale of the gray wallet. The intent behind the attached piece of plastic, which creates the illusion of paint dripping onto the wood construction below, is unknown. It may be a reverential or satiric reference to the so-called "drip paintings" created by Jackson Pollock in the 1940s and 1950s (see page 6). Or perhaps it serves as a reminder of the fact that, in spite of the painting's machine-like precision, *Nomad* was created by an actual person.

Early in his career, Franz Marc painted rhythmic, vividly colored landscapes inhabited by graceful and content animals such as horses, cows, and deer to reflect his belief in the unifying energy that flows throughout creation. His vision changed, however, with the outbreak of the Balkan War, which ultimately led to World War I. In the Gallery's painting, which was meant as a warning against the horrors and the folly of war, Marc's peaceful animals have been replaced by wolves, who, as stand-ins for human beings, destroy everything in their path, and even turn to attack one another. The landscape, too, is in turmoil, with green flames burning in the foreground and purple explosions in the distance. The only symbol of beauty and hope in this work—flowers—are dying in the lower right corner. Marc willingly enlisted to serve in World War I, believing that the war would, in the end, serve as deliverance: from society's materialism to a spiritual and true union with nature. Devastated by the great loss of life, both human and animal, which resulted from the war, he was himself killed at Verdun in 1916 while delivering a message on horseback.

**FRANZ MARC**
(German, 1880–1916).
*Die Wölfe (Balkankrieg)*
*[The Wolves (Balkan War)]*,
1913. Oil on canvas,
27⅞ x 55 inches
(70.8 x 139.7 cm).
Charles Clifton, James G.
Forsyth, and George W.
Goodyear Funds, 1951.

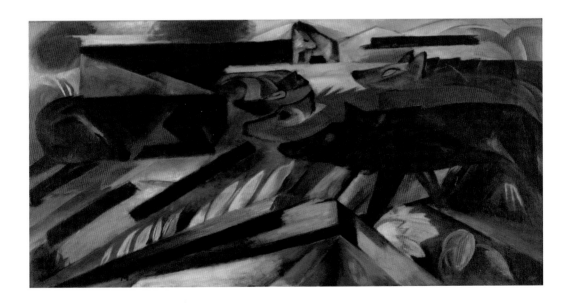

Mark Bradford recalls the Civil Rights Movement in the title of his immense collage *Mississippi Gottdam*, which refers to the song "Mississippi Goddam," written and recorded by Nina Simone in the early 1960s. The song's lyrics criticize those who advocated that the Civil Rights Movement should progress slowly and with caution. The theme of the work—which evokes a surge of water sweeping away everything in its path and includes scraps Bradford collected from the streets of New Orleans—is the devastation caused by Hurricane Katrina in Louisiana and Mississippi in 2005. Taken together, the title and the image have another connotation: the shamefully slow pace of recovery from the disaster, especially in the region's poorer areas.

**MARK BRADFORD**
(American, born 1961).
*Mississippi Gottdam*, 2007.
Mixed media collage on canvas, 102 x 144 inches
(259.1 x 365.8 cm).
George B. and Jenny R. Mathews Fund, 2008.

Philip Taaffe's *Locus Auratus* incorporates Islamic-inspired designs printed with linoleum blocks, acrylic washes of red and blue, and thin sheets of 24-karat gold applied with a special process invented by the artist. The artist's use of gold leaf refers to Byzantine Christian art, in which gold backgrounds were often used to separate holy figures from the material world. By combining Islamic and Christian references, Taaffe seeks to achieve a more general feeling of spirituality. He also evokes the natural world with the illusion of waves, which he chose to highlight in the work's title. *Locus* is Latin for *place* or *location*; *Auratus* refers to a number of species of fish and shares its root with the Latin word for gold, *aurum*. Taaffe explained his ultimate goal for complex works like this by saying, "I think the best thing one can hope for is to be able to enter into another world,"[6] a world, perhaps, where everything joins together in rhythm and harmony.

**PHILIP TAAFFE**
(American, born 1955).
*Locus Auratus*, 2005.
Mixed media on canvas,
120½ x 96½ inches
(306.1 x 245.1 cm).
Gift of Mrs. George A.
Forman, by exchange,
2007.

To create *Heaven and Hell*, Siebren Versteeg wrote an extremely complicated algorithm instructing a computer to search the Internet, in real time, for images returned in Google searches for the words *heaven* and *hell* and then incorporate them into the work's composition. As new images are added, previous ones are removed. Items found through the search term *heaven* appear above the central horizontal line, and those found searching *hell* are placed below. This division, when considered along with the title, evokes Christian paintings of the Last Judgment in which Jesus decides who will go up to heaven and who will go down to hell. Further adding to this interpretation, the overall tone of the top half is blue, traditionally a color of spirituality, while the lower half has an overall reddish cast, evoking the fires of hell. After watching for even a short time, however, viewers will realize that religion is far from the only reference for the words *heaven* and *hell*. This work also offers other avenues for thought, including the role computers and the Internet play in today's society—here they perform the function of an artist.

**SIEBREN VERSTEEG**
(American, born 1971).
*Heaven and Hell*, 2009.
Internet-connected
computer program on
58-inch plasma screen.
George B. and Jenny R.
Mathews Fund, by
exchange, 2010.

**ISAAC JULIEN**
(British, born 1960). *Western Union: Small Boats*, 2007. Three-screen projection: 35mm color film, DVD/HD transfer, 5.1 SR sound, edition 5/5. Running time: 18 minutes, 22 seconds. Gift of Mrs. George A. Forman, by exchange and Charles Clifton Fund, by exchange, 2009.

The immigration of African and Asian so-called "clandestines" from North African shores to Italy, in search of refuge from war, famine, and repression, is a frequent topic of international debate and a source of political tension in the nations involved. The journey across the Mediterranean Sea is close to one hundred miles, and although it begins in larger boats, partway through the crossing the refugees are transferred to small and overcrowded vessels that are set adrift, leaving the immigrants vulnerable and at risk. Sometimes local fishermen who encounter the small boats before they are found by the coast guard do not report them; the resultant deaths have been referred to as the "Sicilian Holocaust." To stunning and moving effect, Isaac Julian contrasts the beautiful city of Agrigento, on the southern coast of Sicily, and the sumptuous eighteenth-century Palazzo Valguarnera-Gangi in Palermo, with images of the dangerous voyages that are undertaken in hopes for a better life. *Western Union: Small Boats* is not a narrative; instead, it is a collage of imagery and sound intended to make viewers pay attention and think.

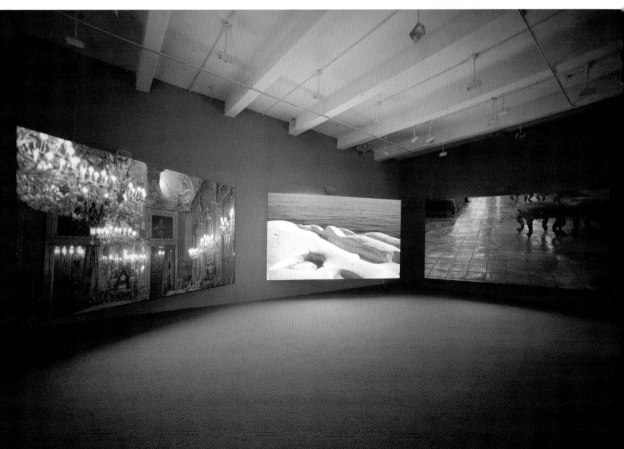

**IT'S ALL THERE
IN BLACK
AND WHITE**

The pairing of black and white is often used as a potent symbol of opposing forces, such as life and death, or good and evil. The dramatic combination of the two is also frequently employed for visual effect in fields including fashion, interior design, and the arts. Ellsworth Kelly's powerful use of black and white in *New York, NY* conveys the scale, drama, and energy of the city. Anne Spalter's digital video drawing creates the opposite effect; shown on a relatively small screen, her image slowly

**1**

**ELLSWORTH KELLY**
(American, born 1923).
*New York, NY*, 1957. Oil
on canvas, 73¼ x 91 inches
(186.1 x 231.1 cm). Gift of
Seymour H. Knox, Jr., 1959.

**2**

**ANNE SPALTER**
(American, born 1965).
*Fracture* from the series
"Internal Energies," 2011.
Digital video drawing,
edition 1/3. Running time:
61 seconds. From the
collection of Dr. & Mrs.
Joseph A. Chazan, 2011.

**3**

**FREDERICK HAMMERSLEY**
(American, 1919–2009). *Bilingual*,
1965. Oil on linen, 51 x 34 inches
(129.5 x 86.4 cm). Albert H. Tracy
Fund, by exchange, 2009.

1

transforms itself, transfixing and calming viewers with its continual, elegant motion. Knowing that many people have a difficult time understanding geometric abstraction, which he once called "the worst kind of paintings to show the American layperson," Frederick Hammersley provided titles for his works that he hoped might help: "It's like I'm giving them an opening wedge to get into the painting."[1] The title *Bilingual* has a unifying connotation and relates to the way black and white in the work are presented in communication and balance.

2

3

# MEMORY

Since its beginnings, art has been a vital part of cultural memory, recording important people, places, and events throughout the course of history. Memory is one of the most influential and important aspects of human culture—the means by which we place ourselves in time and space. Recalling the past and learning from it help us to repeat successes and avoid repeating mistakes. On an individual level, memory allows us to function effectively; it is so important that many people would choose to have their bodies decay before their minds. Memory is not infallible, however: our overall memory can be selective, and some individual memories may transform over time.

**KARA WALKER**
(American, born 1969). Detail from *Emancipation Approximation*, 2000. Portfolio of twenty-seven screen prints on paper, edition 15/20, 44 x 34 inches (111.8 x 86.4 cm). Sarah Norton Goodyear Fund, 2003.

In her twenty-seven screen prints entitled *Emancipation Approxima-tion*, Kara Walker explores African American history and the nature of equality. As the title implies—in its reference to Abraham Lincoln's 1863 Emancipation Proclamation and the abolition of slavery—"freedom" is a relative term. Walker's imagery, which utilizes the look of traditional cut-paper silhouettes, is derived from several sources: narratives of Southern plantation life and the abuse of female slaves by white male landowners; Greek mythology, such as the story of Leda and the Swan in which Zeus, king of the gods, in the form of a swan, rapes or seduces and impreg-nates the married Leda; and the Uncle Remus stories, a collection of African American folktales adapted by the white author Joel Chandler Harris, which are often viewed as demeaning in their characterization and dialect. Walker's series contains numerous historical stereotypes, includ-ing the mammy, the pickaninny, the slave girl, the plantation boss, the master, and the Southern belle. *Emancipation Approximation* does not present a traditional type of narrative; instead, Walker has explained that the work came from a process of free association, which leaves viewers to come up with their own stories and meaning.

*Triptych with Footprints* captures Antoni Tàpies's personal response to the loss of his close friend and art dealer, Martha Jackson. In fact, when Tàpies received a telegram informing him of Jackson's death, he nailed it to the studio wall and later embedded the nail in the surface of the painting. Further, the impressions on the right panel evoke the type of necklace that Jackson often wore. The footprints seen in the work imply a lone figure, presumably Tàpies himself, walking along a beach making marks in the sand with a stick. The artist described this work as "the passage of a person,"[1] and, at its most basic level, it illustrates the physical passage of a person walking on the beach, thinking about the loss of a friend. The footprints in the sand, which will soon be washed away, expand the implications to include the passage of a person through time and the cycle of life and death, which is as unstoppable as the tides. The triptych form relates to traditional Christian altarpieces, which often feature a center panel depicting Christ dying on the cross to ensure his followers' entry into heaven. This perhaps implies that Tapies's notion of a "passage" includes that of the soul from this world to the next.

**ANTONI TÀPIES**
(Spanish, born 1923). *Triptych with Footprints*, 1970. Mixed media on canvas, 57½ x 133½ inches (146.1 x 339.1 cm). Gift of Mr. and Mrs. David K. Anderson to The Martha Jackson Collection, 1977.

Mona Hatoum's *+ and -* is quiet and subtle in its implications and in part reflects her position as a British artist of Palestinian descent. Hatoum's family left Haifa, Israel, in 1948 because of the Arab-Israeli War and settled in Beirut, Lebanon, where she was born in 1952. While Hatoum was visiting London in 1975, the beginning of the Lebanese Civil War prevented her return home. Hatoum's personal history is only one aspect of the potential meaning of *+ and -*, as we each interact with the sculpture based on our own experiences and memories. Many viewers recall visits to the beach, enjoy the quiet sound, and are immersed in the work's hypnotic quality as the arm continues around and around at a consistent rate of speed. One side of the arm contains toothed projections that carve even rows in the sand; the other is a flat edge that erases them. Like culture and history, the surface constantly changes, yet also remains the same, conjuring thoughts of not only creation and destruction, but also the making and erasure of history and memory and the displacement and resettlement of populations.

**MONA HATOUM**
(Palestinian, born 1952).
*+ and -*, 1994–2004. Steel, aluminum, sand, and electric motor, 10⅝ inches (27 cm) high, 157½ inches (399.4 cm) diameter. General Purchase Funds, 2007.

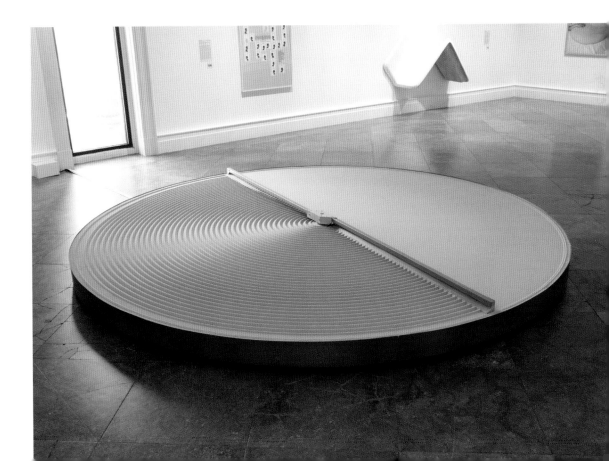

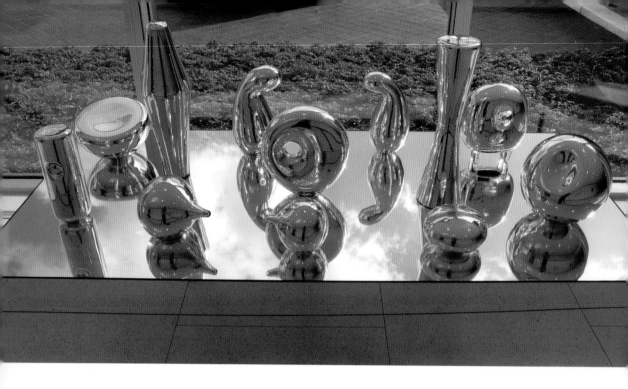

Master glassblower Josiah McElheny is interested in how, as he once stated, "Memory is always an imperfect remembrance." He further notes that as he discovers inspiration in images and stories from the past, he often creates "a new memory of [an] anecdote that's not really real in terms of what it was at that time."[2] The title and forms of this piece were inspired by a 1929 conversation between the architect and inventor R. Buckminster Fuller and the sculptor Isamu Noguchi about the possibility of creating a three-dimensional object that would cast no shadow. Here, incorporating forms designed by Noguchi, McElheny builds on their conclusion: that the object would have to be completely reflective in a reflective setting. In addition to the resulting distorted physical reflections, McElheny also considers the idea of psychological reflection, which is an important part of memory. On yet another level, these works are "about a kind of utopia. The utopia where everything is connected. Everything is a perfect, seamless unity. There is something very beautiful about that, but . . . it's not hard to see how it becomes awful really quickly."[3]

**JOSIAH MCELHENY**
(American, born 1966).
*Buckminster Fuller's Proposal to Isamu Noguchi for the New Abstraction of Total Reflection*, 2003.
Mirror and glass,
52 x 72 x 34½ inches
(132.1 x 182.9 x 87.6 cm).
Sarah Norton Goodyear Fund, 2003.

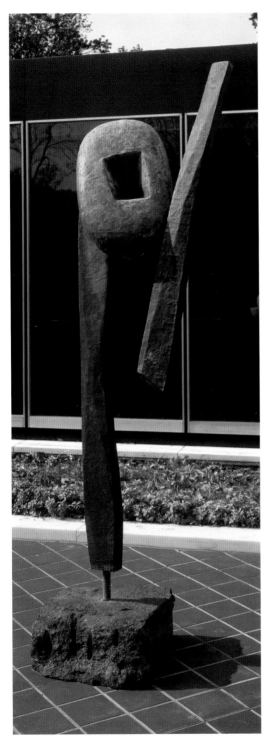

Isamu Noguchi originally created *The Cry* in 1959 from balsa wood as an attempt to create the lightest sculpture possible; it was cast into bronze several years later. The title reflects the sculpture's forms, which are reminiscent of an arm raised alongside an open mouth. In part because his mother was American and his father Japanese, Noguchi's work was influenced by both Eastern and Western cultures, past and present. Funded by the Mellon family's Bollingen Foundation, the artist traveled extensively between 1949 and 1956 to countries such as Japan, China, Nepal, Egypt, and Cambodia. The ancient monuments, temples, and art he explored and photographed during his travels inspired much of his later work. Noguchi's combination of these ancient forms with modernist ideas led to the creation of influential work in numerous fields, including sculpture, architecture, gardens, and interior design.

**ISAMU NOGUCHI**
(American, 1904–1988).
*The Cry*, 1962. Bronze,
81 x 27 x 20 inches (205.7
x 68.6 x 50.8 cm). George
Cary and Elisabeth H.
Gates Funds, 1963.

The ghost-like mood of Kelly Barrie's works—which often evoke powerful feelings of memory and loss—is the result of the artist's unusual creation process. For each work in his series "Between the Blinds," Barrie began with a found photograph of something that had been destroyed. For *Mirror House*, the image was a tree ravaged by Hurricane Katrina in 2005. He transferred the image onto black paper on the floor of his studio, then applied photoluminescent pigment, using his feet to paint with it. Over time, he photographed the changing image, using the natural light that entered the space through the vertical blinds on his window to activate the pigment (hence the series title "Between the Blinds"). He then enhanced and combined these photographs using computer software. The final image inspires notions of memory and the passage of time, marked by the insect trails and cat paw prints that were left during the work's lengthy creation process.

**KELLY BARRIE**
(British, born 1973).
*Mirror House* from the
series "Between the Blinds,"
2010. Archival light jet print,
edition 1/2, 89 x 120 inches
(226.1 x 304.8 cm). Gift of
Seymour H. Knox, Jr. and
the Stevenson Family
Fund, by exchange, 2010.

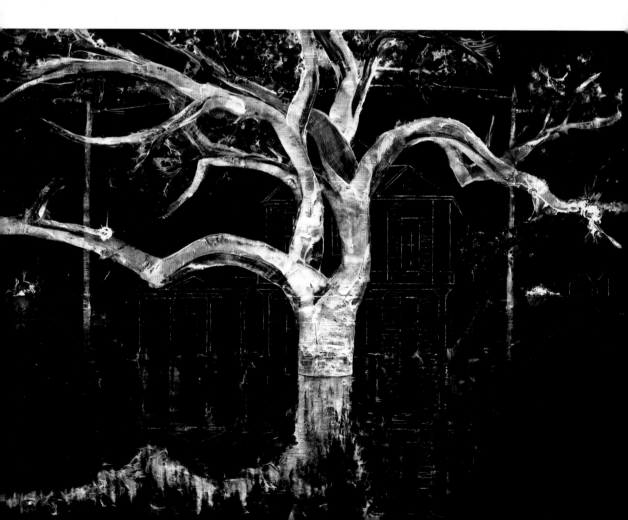

**GARY SIMMONS**
(American, born 1964).
*D.C. Pavillion*, 2007. Pig-
ment, oil paint, and cold
wax on canvas, 84 x 120
inches (213.4 x 304.8 cm).
George B. and Jenny R.
Mathews Fund, by ex-
change, 2008.

In *D.C. Pavillion*, Gary Simmons looks back to the 1965 Watts Riots in Los Angeles and the 1972 film *Conquest of the Planet of the Apes*, which has been viewed as a metaphor for racial issues. The fires in Watts, the flames in the painting, and the idea of people becoming "fired up" recall a line in the film, spoken by the ape leader: "We have passed through the night of the fires," after which the apes had emerged victorious. The building depicted in this painting, which never actually burned, is the Dorothy Chandler Pavilion, constructed between 1962 and 1964 and used frequently as a venue for Academy Awards ceremonies. Related works by Simmons show other flaming structures in Los Angeles, including parts of Century City, which served as a set for the film. In *D.C. Pavillion*, the artist used wax mixed with red paint to create a rich surface, which, along with his smearing technique, also makes the building appear ghostlike. The spectral appearance may also refer to memory, perhaps reminding us that forgetting the past is often a detriment to the present and the future.

**JIŘÍ KOLÁŘ**
(Czech, 1914–2002).
*Cycladic Heads*, 1976.
Chiasmage on wood,
15½ x 17¾ x 5⅞ inches
(39.4 x 45.1 x 14.9 cm).
Evelyn Rumsey Cary
Fund, 1977.

While visiting the Albright-Knox in the mid-1970s, Jiří Kolář became fascinated by a female figure created by the ancient culture that was centered in the Cyclades Islands, off the coast of Greece, around 3200–2300 BCE. He purchased a reproduction of a Cycladic head in the Gallery's shop and had it reproduced to create this work, which celebrates Greek contributions to Western civilization. The head on the left is covered with a text in Latin that refers to the fifteenth-century humanist scholars who revived ancient learning in the period known as the Renaissance. The wax seals refer to the wealthy patrons of this scholarship. The central head is collaged with a star chart, reflecting Greek contributions to astronomy and reminding us that we still use their names for the constellations today. The third head features musical notations and fragments of poetry, at which the ancient Greeks also excelled. The base, covered with classically inspired sixteenth-century imagery, imitates the Olympic medal stand. The Olympic Games were born in Greece, and Kolář created this in an Olympic year, which brings the sculpture full circle and ties the past to the present in even more tangible ways.

The American Civil Rights Movement serves as the backdrop for Kelley Walker's work *Black Star Press (rotated 90 degrees counterclockwise); Press, Black Star*. The underlying photograph shows a white police officer grabbing the collar of a young African American man, as a German Shepherd leaps forward. The original image was taken in the 1960s during the race riots in Birmingham, Alabama, but continues to have resonance in contemporary society. The artist has enhanced the inherent confusion of such incidents in two ways: first, by turning the photograph ninety degrees, making it more difficult to read; and second, by obscuring much of the image with silkscreened white and dark chocolate, which symbolically parallels the clash of colors pictured in the background. By using the same photograph in this and a number of similar works, Walker alludes to the effects of contemporary mass media and its 24-hour coverage of compelling events. The viewing public, faced with constant reminders of all of the world's problems, becomes desensitized, so that we either ignore what is going on or become so used to it that it no longer affects us emotionally.

**KELLEY WALKER**
(American, born 1969).
*Black Star Press (rotated 90 degrees counterclockwise); Press, Black Star*, 2006. Digital print with silkscreened chocolate on canvas, 83 x 104 inches (210.8 x 264.2 cm). Charlotte A. Watson Fund, by exchange, and Gift of Mrs. Seymour H. Knox, Sr., by exchange, 2008.

Aristide Maillol's heavy lead sculpture seems to personify the idea of *night* in its extreme stillness and closed position, with the figure's head and hands resting on her knees, almost as if she is asleep. Night is also a time of contemplation and wonder as we look up at the star-filled universe, which Vija Celmins slowly and painstakingly re-created in a print that she has described as "a record of some intense looking . . . , a disappearance of time, a feeling of innocence,

2

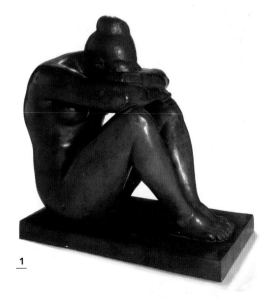

1

**1**
**ARISTIDE MAILLOL**
(French, 1861–1944). *Night*, 1902–09 (cast executed 1939). Lead, 41½ x 24 x 43½ inches (105.4 x 61 x 110.5 cm). James G. Forsyth Fund, 1939.

**2**
**VIJA CELMINS**
(American, born Latvia, 1939). *Starfield*, 2010. Two-plate, one-color mezzotint on Hahnemuhle Copperplate bright white paper, 26¼ x 35 inches (66.7 x 88.9 cm). Bequest of Mortimer Schiff, by exchange and Gift of Mrs. Richard J. Sherman, by exchange, 2010.

of silence."[1] René Magritte, in *The Voice of Space*, was thinking about how sounds can travel over great distances through the silence of the night. Although today the spheres in his painting might conjure up ideas of mysteriously lit UFOs, Magritte was thinking about the jingle of iron bells on horses' collars, which reverberated through the night air. Magritte added slits to the spheres to represent the mystery of human life, which we will never fully understand, just as we strive but fail to discover the secrets of the universe, or to explain our dreams.

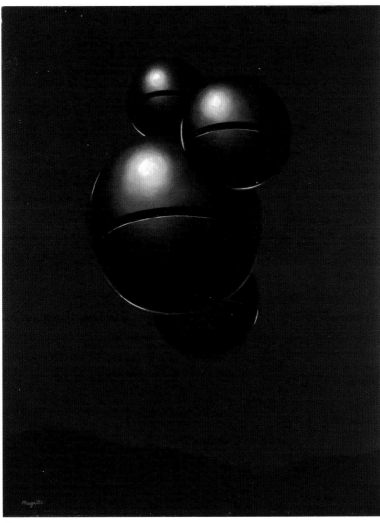

**3**
**RENÉ MAGRITTE**
(Belgian, 1898–1967).
*La Voix des airs (The Voice of Space)*, 1928. Oil on canvas, 25½ x 19½ inches (64.8 x 49.5 cm). Albert H. Tracy Fund, by exchange, and George B. and Jenny R. Mathews Fund, 1976.

3

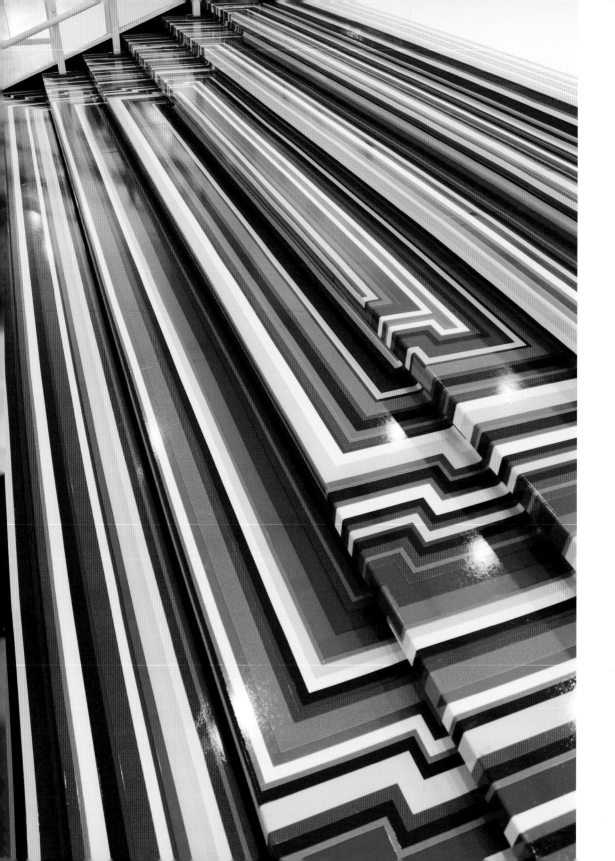

# THE MUSEUM AS CANVAS

The Albright-Knox Art Gallery's Collection includes numerous works of art that use the museum walls, floors, and ceilings as much more than just a backdrop or support. These works' relationships with the building vary: some are commissions, designed to reside in specific areas; others were redesigned to accommodate a Gallery space; some, when not on view, exist only in the form of diagrams or installation instructions.

**JIM LAMBIE**
(Scottish, born 1964).
*Zobop Stairs*, 2003.
Vinyl tape, dimensions
variable. George B. and
Jenny R. Mathews Fund,
by exchange and Gift
of Dennis and Debra
Scholl, 2010.

Although the powerful optical illusion created by Jim Lambie's *Zobop Stairs* literally stops people in their tracks, the stunning visual effect is not the artist's primary concern. One of his main goals is to empty and fill a space at the same time—covering the stairs with tape fills the space visually but does not take up actual physical space. In addition, with a work like this, Lambie is responsible for only a certain number of decisions: "The architecture completely controls the piece—the only thing I'm really doing is choosing the colors and the width of the tape because the shape and the pace of the piece is completely controlled by the architecture, which for me is kind of nice—it means I don't have to think too much about it."[1] Visitors, however, *do* have to think carefully in order to safely navigate this popular work.

Sarah Sze's *Second Means of Egress (Orange)*, which was inspired by fire escapes in New York, can be installed almost anywhere. The artist leaves it up to museum personnel to decide exactly how the separate pieces will be arranged, and how many of them will be included, because it is not necessary to install all of them at the same time. Sze worked with a manufacturing company to create laser-cut steel sections that were then welded together according to the artist's specifications before being coated with orange powder and cured. The playfulness of the work cannot be ignored, as visitors imagine miniature versions of themselves within the forms, climbing and exploring. But certain installations, such as the one pictured here, in one of the Gallery's stairwells, present numerous dead ends from which there is no obvious means of egress.

**SARAH SZE**
(American, born 1969).
*Second Means of Egress
(Orange)*, 2004. Steel
and powder, dimensions
variable. Charles W.
Goodyear Fund, 2004.

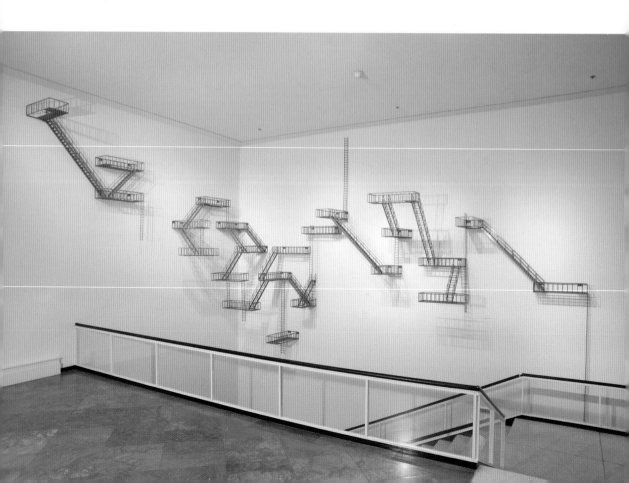

**CORY ARCANGEL**
(American, born 1978).
*MIG 29 Soviet Fighter
Plane and Clouds*, 2005.
Two handmade hacked
Nintendo cartridges and
game systems for multi-
channel projection,
edition 5/5, dimensions
variable. General
Purchase Funds, 2006.

Cory Arcangel once described himself as "a twenty-nine-year-old com-
puter nerd from Buffalo, New York."[2] Many of his installations use older
gaming systems as their sources, for several reasons: "They're cheap!
And technically everything ends up outdated eventually, so one must
learn to not only appreciate the new. Also, since there is quite a lot of
cultural distance between the technology and the present, it produces
quite a lot of freedom in terms of perspective."[3] *MIG 29 Soviet Fighter
Plane and Clouds* was adapted from a game in which players fought
imaginary air battles representing the threat of the Cold War era. Hack-
ing into the game and removing the dogfights, Arcangel created a new
world in which the plane instead soars through the sky. Because the MIG
29 was developed to counter American fighter planes and is currently
still in use by the Russian air force, the work also brings to mind the
continued tension and uncertainty of today's political climate.

It took 1,717 pencil leads, and sixteen scribblers working seven hours a day for fifty-four days, to cover the more than 2,200 square feet of wall surface that make up this work, which is Sol LeWitt's largest—and his last—scribble wall drawing. Designed specifically for the stairwell that connects the 1905 Albright Building with the 1962 Knox Building, this work was created using the artist's instructions, which were simply, *Line, continuous gradation, and feel of steel.* He also provided a small model for use as a guide. LeWitt was one of the country's most prominent Conceptual artists, for whom the *idea* was more important than the *object.* As he explained, "In conceptual art the idea or concept is the most important aspect of the work. When an artist uses a conceptual form of art, it means that all of the planning and decisions are made beforehand and the execution is a perfunctory affair."[4] In the case of each of his influential wall drawings, LeWitt generated the idea, which was then acquired by a collector or museum in the form of guidelines that could be carried out by other artists if a physical object was desired.

152

**SOL LEWITT**
(American, 1928–2007).
*Wall Drawing #1268:
Scribbles: Staircase (AKAG),*
conceived 2006; executed
2010. Graphite on three
walls, dimensions variable.
George B. and Jenny R.
Mathews Fund, 2007. First
drawn by: Darren Adair,
Takeshi Arita, Kyle Butler,
Roshen Carman, Andrew
Colbert, Cynthia Cui,
Katharine Gaudy, Aviva
Grossman, John Hogan,
Ani Hoover, Gabriel Hurier,
Roland Lusk, Amanda
Maciuba, Allison Midgley,
Alyssa Morasco, Joshua
Turner. First Installation:
Albright-Knox Art Gallery,
Buffalo, New York, October
2010.

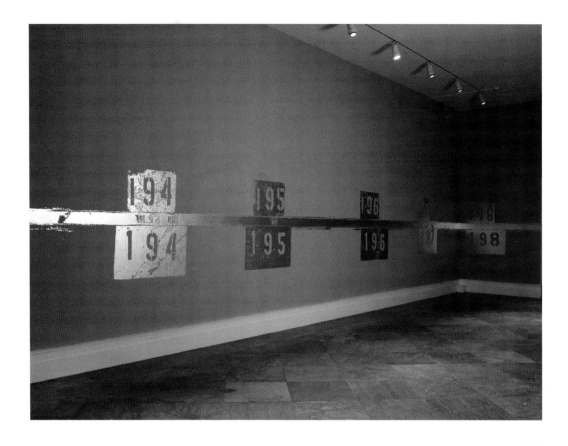

**INGRID CALAME**
(American, born 1965).
*Mittal Steel No. 1 Shipping 192–208*, 2009. Latex and enamel paint, dimensions variable. Multiple Purchase Funds, 2009.

*Mittal Steel No. 1 Shipping 192-208* is a commissioned work by Ingrid Calame, who visited Buffalo several times as part of the museum's first Artist-in-Residence program, which took place from 2007 through 2009. Calame begins her creation process by tracing evidence of human presence in the form of stains, tire tracks, and other marks left behind in various types of locations. While in Buffalo, she worked with area volunteers at several sites, including the ArcelorMittal steel plant, where she and her team traced painted numbers on the factory floor. Through a series of transformations and experiments in the artist's studio, the tracings evolved into this wall painting, which was created at the Gallery. Calame has stated, "The traced numbers, paint, and cracks, like individual workers in a factory . . . , have retained their integrity, but have stopped short of being symbols—they are captured images that combine history, physical fact, decay, memory, and personal experience."[5]

**LIAM GILLICK**
(British, born 1964).
*Expanded production
horizon*, 2008. Powder-
coated aluminum and
transparent Plexiglas, six
parts: 59 x 59 x 2 inches
(149.9 x 149.9 x 5.1 cm)
each. Albert H. Tracy Fund,
Gift of Mrs. George A.
Forman, by exchange,
and Charles W. Goodyear
Fund, 2008.

Following the 2005 exhibition *Extreme Abstraction*, Albright-Knox
Director Louis Grachos and the artist Liam Gillick began a conversation
about commissioned works. Gillick's interest in art serving a function
beyond aesthetics, along with his admiration for the work of the architect
Gordon Bunshaft, who designed the Gallery's 1962 Knox Building, led to
two commissions: one for a corner of the Gallery's café and another for
the Gallery's main entrance on Elmwood Avenue. The primary goal of the
latter work was to mitigate the absence of a lobby by visually distinguish-
ing the entrance without taking up any of the Gallery's limited physical
space. Gillick accomplished this by suspending brightly colored Plexiglas
panels from the ceiling, setting the entry area apart from the whiteness
of the modern-style building and creating a welcoming presence that
visitors often sense before they see.

**ADRIAN SCHIESS**
(Swiss, born 1959).
*Malerei*, 2002–04.
Industrial lacquer on
aluminum sandwich
board, 80 x 81 x 2 inches
(203.2 x 205.7 x 50.1 cm)
each. Multiple Purchase
Funds with donations from
Franz and Sigrid Wojda
(Austria), Rosemarie
Schwarzwalder (Austria),
Manfred and Eva Frey
(Austria), Walter and Maria
Holzer (Austria), Julius Meinl
(Austria), Emmanuelle and
Didier Saulnier (France),
Christian Hauer (Austria)
and Susanna Kulli
(Switzerland), 2006.

Adrian Schiess's large, pristine paintings, which are placed on the floor near sources of natural light, transform their surroundings at the same time their surroundings transform them. The Gallery's eight-panel work *Malerei* (German for "painting") was installed during the 2005 exhibition *Extreme Abstraction* along a hallway that overlooks the Sculpture Garden. Consisting of industrial enamel on aluminum, the work is characterized by an extremely glossy surface made up of colors that are almost impossible to define as they react to people walking by, changes in their immediate surroundings, and weather conditions. Schiess's goal is to provide visitors with an experience that is positive and alive. He has explained, "On the surface of these shiny panels you always see what's happening—what's happening now. . . . [It's] reflection, and it's not steady—it's always moving, it's always changing. And what you see with your own movement, it's impossible to catch. You can't catch this reflection—you can't catch these moving images on the surface, this endless movie which goes on and on on the surface of these paintings. You can't catch them."[6]

Every museum has its public favorites—the works that local residents show to out-of-town guests and ask about when they are not on view. One of the Gallery's most popular pieces is "the lady in the pink dress" (see page 21). Another is Jehan Georges Vibert's scene of a cardinal, who has been experimenting at the stove, and his chef, who seem to have differing opinions on whether or not the sauce is truly "marvel-

1

2

**1**

**JEHAN GEORGES VIBERT**
(French, 1840–1902).
*The Marvelous Sauce*, ca.
1890. Oil on wood panel,
25 x 32 inches (63.5 x 81.3
cm). Bequest of Elisabeth
H. Gates, 1899.

**2**

**MARISOL**
(Venezuelan and American,
born France, 1930). *Baby
Girl*, 1963. Wood and mixed
media, 74 x 35 x 47 inches
(188 x 89 x 119.4 cm).
Gift of Seymour H. Knox,
Jr., 1964. Art © Marisol
Escobar/Licensed by
VAGA, New York, NY.

**3**

**LUCAS SAMARAS**
(American, born Greece,
1936). *Room No. 2* (popu-
larly known as the *Mirrored
Room*), 1966. Mirror on
wood, 96 x 96 x 120 inches
(243.8 x 243.8 x 304.8 cm).
Gift of Seymour H. Knox,
Jr., 1966.

ous." Marisol's huge, smiling baby resonates with parents whose lives have been overwhelmed by the needs of a child whose well-being they have willingly put before their own. Finally, Lucas Samaras's *Room No. 2*, popularly known as the *Mirrored Room*, is remembered by anyone who has walked inside—adding color and motion to the piece as they see themselves reflected thousands of times in all directions—and wondered, "Is there a top on that table, or not?"

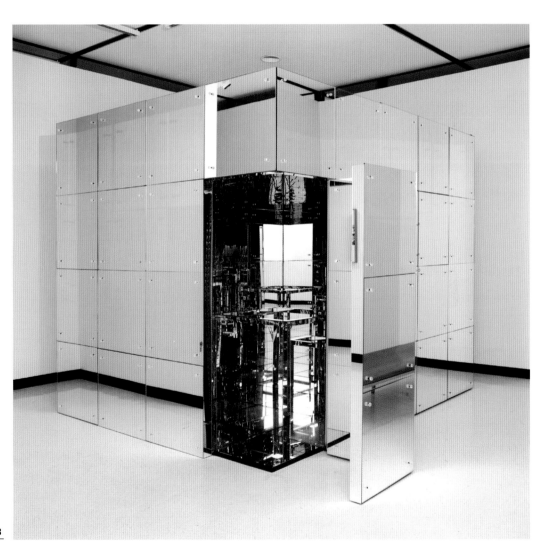

**PHILIP ARGENT**
(British, born 1962).
*Untitled,* 2007. Acrylic on
canvas, 60 x 60 inches
(152.4 x 152.4 cm). Pending
Acquisition Funds, 2011.

This painting, with its vivid
color and unusual forms,
inspires our imagination
as it evokes an out-of-this-
world landscape that would
be difficult to navigate due
to its multiple levels and
perpendicular planes.

**JAYE RHEE**
(Korean, born 1973).
*Tear,* 2002. Four-channel
video installation with
sound, edition 2/5.
Running time: 4 minutes,
7 seconds. Bequest of
Arthur B. Michael, by
exchange, 2011

In this compelling video
installation, Jaye Rhee tears
a white sheet of fabric by
walking through it, reflecting
the perseverance of the
human spirit.

As Philip Taaffe (see page 131) has noted, a work of art can transport us into another world. The same is true of a visit to a museum, where, we hope, a statement by Kiki Smith will prove to be true: "Everybody already knows everything. . . . You already have your own references and you can come to your own associations. Hopefully something in it resonates with enough things that you can think about your own life."[1]

A seemingly endless variety of materials and techniques available to artists, coupled with continued experimentation and innovation, will keep the art world of tomorrow exciting, ever-changing, thought-provoking, and worthy of our attention. And into the future, the Albright-Knox Art Gallery will continue to be committed to fulfilling its mission to collect, exhibit, preserve, and educate visitors about the art of our time.

The works illustrated in this section entered the Collection in 2011, the year of this handbook's publication.

The collector of the past could afford to wait until time had added a patina to the creations of the artist, until taste and tradition had sifted through the spilth of a generation. The collector of today cannot wait on time or rely on tradition. He must take a risk, and his only guide is his own sensibility and judgment . . . . It is easy to falter, to follow a false trail of fashion, to dissipate one's reserves; but the true pioneer is not afraid of these risks, and his reward is to be the first to see the sun rise over the frontiers of a new-found land.

Sir Herbert Read, British poet and critic, at the January 1962 symposium *Pioneering in Art Collecting*, Albright-Knox Art Gallery

**SARAH MORRIS**
(American, born 1967).
*Points on a Line*, 2010.
HDCAM SR tape, edition
2/5. Running time: 35 minutes,
48 seconds. Pending
Acquisition Funds, 2011.

This film focuses on two icons
of modern architecture—
Ludwig Mies van der Rohe's
Farnsworth House, 1951,
in Plano, Illinois, and Philip
Johnson's Glass House, 1949,
in New Canaan, Connecticut—
in an exploration of modern
architecture's intellectual
and visual implications.

**DAVID THORPE**
(British, born 1972).
Detail of *A and C missile*,
2008. Plaster and leather
on plinth, missile: 23¾ x 5¾
x 5¾ inches (60.3 x 14.6 x
14.6 cm), plinth: 52½ x 9 x 9
inches (133.4 x 22.9 x 22.9
cm). Bequest of Arthur B.
Michael, by exchange, 2011.

In works such as this,
David Thorpe combines
design templates from the
turn of the twentieth century
with overlays inspired by
the world of nature.

Like science, art since the beginning of the century has turned to realms that heretofore seemed beyond its reach: it too has sought to render the invisible visible . . . . Because our ideas of matter are new and because our concepts of the human mind are equally new, the artist in our day, as though he were the first man alive, has had to invoke his own unique vision of the spirit of man's involvement with the life process.

Gordon Washburn, Director of the Carnegie Institute Department of Fine Arts and former Director of the Albright Art Gallery, at the January 1962 symposium *Pioneering in Art Collecting*, Albright-Knox Art Gallery

**LARI PITTMAN**
(American, born 1952). *Untitled#2*, 2010. Acrylic, cel-vinyl, and aerosol lacquer on gessoed canvas over panel, 101⅞ x 88 inches (259 x 223.5 cm). Sarah Norton Goodyear Fund, 2011.

Lari Pittman considers his meticulous paintings, which reference graffiti art and both Eastern and Western visual traditions, to be, in part, a protest against male gender stereotypes.

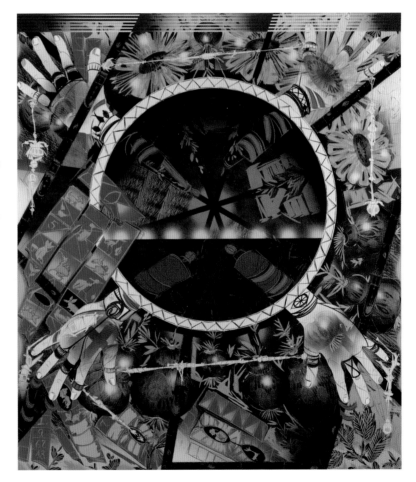

**Real collecting means to be ahead of time, to look for the artist who is about to shape the world of tomorrow . . . . The function of the collector is to care that nothing of real importance or real value is lost. I strongly believe that for modern man the art of today is more important than the art of yesterday. Great artists are living now, and it is our duty to find them, to assist them with conviction, to show their work to those who want to see it, and even to those who do not.**

W. J. H. B. Sandberg, Director, Stedelijk Museum of Contemporary Art, Amsterdam, The Netherlands, at the January 1962 symposium *Pioneering in Art Collecting*, Albright-Knox Art Gallery

**OLIVIER MOSSET**
(Swiss, born 1944). *Untitled*, 1986. Acrylic on canvas, 83½ x 167½ inches (212.1 x 425.5 cm). Pending Acquisition Funds, 2011.

In the 1960s, Olivier Mosset began defining his paintings simply as objects. Lacking references or implications comprehensible only to art-world initiates, his uncomplicated formats are intended to make art more democratic.

**JIM ISERMANN**
(American, born 1955). *#0488*, 1988. Enamel paint on wood, 48 x 48 inches (121.9 x 121.9 cm). Pending Acquisition Funds, 2011.

Jim Isermann's work incorporates both the history of abstract art and the principles of industrial design. Using optical compositions such as the one seen here, he hopes to achieve harmonious balance and proportion.

There is no marking time. Art . . . is always changing but always the same. I have often thought of living art as a bus rolling down a long boulevard. We run to catch it, but it does not stop. We may jump aboard, or we may stand by the curb where we came abreast it. If we do not board it, the bus gradually draws out of sight. We are left with only the after-images of what excited us while we were alongside . . . . But if we board it and stay aboard we can enjoy the new landscapes as they open up on each side and still look back comfortably on the art of the past.

James Johnson Sweeney, Director of the Museum of Fine Arts, Houston, at the January 1962 symposium *Pioneering in Art Collecting*, Albright-Knox Art Gallery

**CASEY COOK**
(American, born 1971). *Mashing up the Clouds*, 2010. Cel-vinyl, acrylic, and pencil on canvas, 58 x 50 inches (147.3 x 127 cm). George B. and Jenny R. Mathews Fund, by exchange, James G. Forsyth Fund, by exchange, Gift of Thomas Robins, Jr. in memory of Louisa Robins, by exchange, Gift of Miss Margaret Mitchell, by exchange, Gift of Mr. and Mrs. Lucien Garo, by exchange and Gift of Arthur B. Michael, by exchange, 2011.

The subject matter in Casey Cook's work is difficult to define. The combination of strange body parts with other imagery creates a surreal atmosphere that seems to become more complex the longer one looks.

# NOTES

## A Contemporary History

1. J. Benjamin Townsend, *100: The Buffalo Fine Arts Academy, 1862–1962*, assisted by Ruth M. Peyton (Buffalo, NY: The Buffalo Fine Arts Academy, 1962), 10.

2. Ibid., 12.

3. Ibid., 31.

4. Leo Villareal, Albright-Knox Art Gallery audio tour, 2005.

## Objects Renewed

1. Lever House Art Collection, "Tom Sachs: Bronze Collection" press release, May 8, 2008.

2. Both quotations are from "2010 Visual Arts Recipient: Rachel Harrison," The Alpert Award in the Arts website, www. alpertawards.org/visualarts.html.

## The World Around Us

1. Susan Krane, with Robert Evren and Helen Raye, *Albright-Knox Art Gallery, The Painting and Sculpture Collection: Acquisitions since 1972*, ed. Karen Lee Spaulding (New York and Buffalo, NY: Hudson Hills Press in association with the Albright-Knox Art Gallery, 1987), 100.

2. *Tara Donovan* (October 10, 2008–January 4, 2009), The Institute of Contemporary Art/Boston website, www. icaboston.org/exhibitions/exhibit/donovan/audio-visual/.

3. Hugh Eakin, "Photographing Non-places," *ARTnews* (March 2002): 98.

4. Calvin Tomkins, "The Pour," *The New Yorker,* March 13, 2006, www.newyorker. com/archive/2006/03/13/060313ta_talk_ tomkins.

5. Both quotations are from Gary Michael Dault, "The Twilight Avenger is not what he seems," *The Globe and Mail*, August 9, 2008, www.kellyrichardson.net/globe2008. htm.

6. Clare Woods, email to the Albright-Knox Art Gallery, February 2005.

7. Both quotations are from "Matthew Ritchie on *Morning War* and *The Holstein Manifesto*" (Interview with Heather Pesanti), Albright-Knox Art Gallery website, www. albrightknox.org/news-and-features/ features/article:matthew-ritchie-on-morning-war-and-the-holstein-manifesto/.

8. JoAnne Northrup, *Jennifer Steinkamp* (Munich: Prestel Publishing, 2006), 93.

9. Joan Seeman, "Interview with Nancy Graves," New York, June 6, 1979 (unpublished); excerpt published in Linda L. Cathcart, *Nancy Graves: A Survey, 1969/1980* (Buffalo, NY: Albright-Knox Art Gallery, 1980), 22.

## City Life

1. Krane, with Evren and Raye, *Acquisitions since 1972*, 324.

2. "Water-colors by John Marin," *Camera Work*, Nos. 42–43 (April–July 1913): 18.

3. Steven A. Nash, with Katy Kline, Charlotta Kotik, and Emese Wood, *Albright-Knox Art Gallery: Painting and Sculpture from Antiquity to 1942* (New York and Buffalo, NY: Rizzoli in association with the Albright-Knox Art Gallery, 1979), 524.

4. Rufino Tamayo, *Rufino Tamayo: Myth and Magic* (New York: The Solomon R. Guggenheim Foundation, 1979), 23.

5. Claire Schneider, *Passion Complex: Selected Works from the Albright-Knox Art Gallery* (Kanazawa, Japan: 21st Century Museum of Contemporary Art, 2007).

6. *Cruel and Tender: The Real in the Twentieth-century Photograph* (June 5–September 7, 2003), Tate Modern website, www.tate.org.uk/modern/exhibitions/ cruelandtender/dicorcia.htm.

## Larger Than Life

1. Tony Smith, *Tony Smith: Two Exhibitions of Sculpture* (Hartford, CT, and Philadelphia: Wadsworth Atheneum and The Institute of Contemporary Art, 1966), 24.

## On the Inside

1. Fred Sandback, "Remarks on my Sculpture 1966–86," in *Fred Sandback: Sculpture, 1966–1986* (Munich: Fred Jahn, 1986), 12.

2. *74 Front Street: The Fred Sandback Museum, Winchendon, Massachusetts* (New York: The Fred Sandback Museum, 1982), 4.

3. Bradford Morrow, "Crewdson: Interview," *BOMB* 61 (Fall 1997).

4. Murray Whyte, "Making room to revisit a movie classic," *Toronto Star*, November 13, 2010.

5. Elizabeth Weiner, "Pipilotti Rist," *Whitewall Contemporary Art and Lifestyle Magazine*, September 24, 2010, www. whitewallmag.com/2010/09/24/pipilotti-rist/.

6. Holly E. Hughes, Introductory text for the exhibition *Pipilotti Rist: Dwelling (within)* (March 18–June 4, 2011), Albright-Knox Art Gallery.

7. Both quotations are from Katy Donoghue, "Erwin Wurm," *Whitewall Contemporary Art and Lifestyle Magazine* (Spring 2011): 114.

8. Robert L. Herbert, *Georges Seurat 1859–1891* (New York: The Metropolitan Museum of Art, 1991), 344.

## Full Circle

1. "Mariko Mori's Wave UFO," Public Art Fund press release, May 2003.

## Human | Nature

1. Sonja Braas, "The Quiet of Dissolution," Galerie Tanit website, www.galerietanit. com/bios/braas/braas.htm.

2. "Kiki Smith," Galerie Fortlaan 17 website, www.fortlaan17.com/artists/ kiki-smith/context.lasso?-session=s: 42F942EF1890223766iqxp445528.

3. Robert Ayers, "Robert Ayers in conversation with Kiki Smith," *A Sky filled with Shooting Stars*, February 15, 2010, www.askyfilledwithshootingstars.com/ wordpress/?p=1128.

4. Heidi Zuckerman Jacobson and Phyllis Wattis, Brochure for the exhibition *A Maximum Minimum Time Space Between Us and the Parsimonious Universe* (February 18–April 15, 2001), University of California, Berkeley Art Museum and Pacific Film Archive website, www.bampfa.berkeley. edu/images/art/matrix/190/MATRIX_190_ Ernesto_Neto.pdf.

5. Martin Gayford, "Ernesto Neto interview for Festival Brazil: Realm of the senses," *The Telegraph*, May 28, 2010, www.telegraph.co.uk/culture/art/art-features/7772975/Ernesto-Neto-interview-for-Festival-Brazil-realm-of-the-senses.html.

6. Joan Simon, "Bruce Nauman: The Matter in Hand," *TATE* (June 1, 1998).

7. Both quotations are from Erin Clark, "Alison Saar," *ARTWORKS Magazine* (Winter 2008), artworksmagazine.com /2009/03/alison-saar/.

8. Paul Gardner, *Neil Jenney: The Bad Years 1969–70* (New York: Gagosian Gallery, 2001), 11.

9. John D. Morse, "Henry Moore Comes to America," *Magazine of Art* 40, No. 3 (March 1947).

10. Bill Hall, preface to the catalogue for *The Messenger*, 1996, www.artschaplaincy. org.uk/commissions/messenger.html.

11. Bill Viola, Artist's statement for the exhibition *Bill Viola: The Messenger* (February 19–March 13, 1997), South London Gallery website, southlondongallery.org/page/bill-viola-the-messenger.

12. Ibid.

## A Sense of Belonging

1. Both quotations are from Douglas Dreishpoon, "Janine Antoni," *Art in America* (October 23, 2009), www. artinamericamagazine.com/features/ janine-antoni/3/.

2. Art21, "Erasure, Camouflage, & 'Four Horsemen of the Apocalypse'" (Interview with Paul Pfeiffer), *Art21* Season 3, 2005, www.pbs.org/art21/artists/pfeiffer/clip1. html.

3. Shana Nys Dambrot, "Interview: Catherine Opie," *Artkrush* 36 (July 12, 2006), artkrush.com/29508.html.

4. John Slyce, "That Essence Rare: Gillian Wearing's Family Album," *Contemporary* 55 (October 2003): 27–29.

5. Both quotations are from the audio file for "Past Exhibitions: Colour Chart," Tate Liverpool website, www.tate.org.uk/liverpool/exhibitions/colourchart/artists/weems.shtm.

6. "Byron Kim: *Synecdoche*," MoMA Multimedia, The Museum of Modern Art website, www.moma.org/explore/multimedia/audios/34/807.

7. Romare Bearden in a letter to Helen Raye, a researcher for the Albright-Knox Art Gallery, August 25, 1984, Romare Bearden Documentation file, Registrar Collection, Collection Albright-Knox Art Gallery.

### It Takes All Kinds

1. Anne-celine Jaeger, "A Conversation with Rineke Dijkstra," PopPhoto.com, December 16, 2008, www.popphoto.com/how-to/2008/12/conversation-rineke-dijkstra?page=0,1.

2. Karen Lee Spaulding, ed., *Masterworks at the Albright-Knox Art Gallery* (New York and Buffalo, NY: Hudson Hills Press in association with the Albright-Knox Art Gallery, 1999), 280.

3. Deutsche Börse Group, "Thomas Ruff: Dermatological realism," Deutsche Börse Group website, deutsche-boerse.com/dbag/dispatch/en/kir/gdb_navigation/about_us/30_Art_Collection/40_artists/04_M-R/58_ruff?horizontal=page0_db_sp_ruff_thomas.

4. Carl Dietrich Carls, *Ernst Barlach* (New York: Frederick A. Praeger, Publishers, 1969), 9.

5. Art21, "Childhood & Influences" (Interview with Iñigo Manglano-Ovalle), *Art21* Season 4, 2007, www.pbs.org/art21/artists/manglanoovalle/clip1.html.

6. Both quotations are from Arthur Lubow, "The Luminist," *The New York Times Magazine*, February 25, 2007, www.nytimes.com/2007/02/25/magazine/25Wall.t.html.

7. Meghan Dailey, "A Thousand Words: Justine Kurland—Brief Article," *Artforum* (April 2000).

8. Friedrich Teja Bach, Margit Rowell, and Ann Temkin, *Constantin Brancusi, 1876–1957* (Philadelphia: Philadelphia Museum of Art, 1995), 64.

9. Malvina Hoffman, *Sculpture Inside and Out* (New York: W. W. Norton & Company, 1939), 52.

### Cut It Out

1. ArtCat, "Mark Fox, *Monstr*," ArtCat website, www.artcat.com/exhibits/11495.

### A Common Language

1. "Lorna Simpson," Museum of Contemporary Photography website, www.mocp.org/collections/permanent/simpson_lorna.php.

2. *I Heard a Voice: The Art of Lesley Dill* (January 17–April 19, 2009), Hunter Museum of American Art website, www.huntermuseum.org/exhibition/7/i-heard-a-voicethe-art-of-lesley-dill/.

3. Interview with Lesley Dill about her work in the special exhibition *Materials, Metaphors, and Narratives: Work by Six Contemporary Artists* (October 4, 2003–January 4, 2004), Albright-Knox Art Gallery, October 2003.

4. Glenn Ligon, *Glenn Ligon Stranger* (New York: The Studio Museum in Harlem, 2001), 28.

5. "Vik Muniz's *Verso*," Exposure Project website, September 5, 2008, theexposureproject.blogspot.com/2008/09/vik-munizs-verso.html.

6. Rachel Wolff, "Emin Inc.," *Town & Country* (May 2011).

7. Lehmann Maupin Gallery, press release for the exhibition *Only God Knows I'm Good* (November 5–December 19, 2009), Lehmann Maupin Gallery website, www.lehmannmaupin.com/#/exhibitions/2009-11-05_tracey-emin/.

8. Both quotations are from Martin Gayford, "Ed Ruscha: Interview," *The Telegraph*, September 25, 2009, www.telegraph.co.uk/culture/art/art-features/6224022/Ed-Ruscha-interview.html.

9. "Collections of The Castellani Art Museum: Artwork of the 80's," Castellani Art Museum of Niagara University website, purple.niagara.edu/cam/special/Art_of_80s/Artists/dwyer.html.

10. Ilaria Gianni, "Interview with Stefan Brüggemann," *Arte e Critica* 51 (June–August 2007), www.stefanbruggemann.com/bibliography/14.html.

11. "Opening: Francine Savard" (Video interview with Michael Hansen), ArtSync website, January 21, 2011, www.artsync.ca/opening-francine-savard/.

12. Georges Perec, *Un homme qui dort* (Paris: Denoël, 1967); Georges Perec, *Things: A Story of the Sixties; A Man Asleep*, translated by David Bellos and Andrew Leak (London: Harvill Press, 1990).

### Let There Be Light

1. Craig E. Adcock, *James Turrell: The Art of Light and Space* (Berkeley: University of California Press, 1990), 114.

### Cultural Commentary

1. "Portrait/Homage/Embodiment," The Pulitzer Foundation for the Arts website, portrait.pulitzerarts.org/entrance-gallery/atrabiliarios/.

2. Craig Gholson, "Robert Gober," *BOMB* 29 (Fall 1989), bombsite.com/issues/29/articles/1252.

3. Ibid.

4. Bill Kelley, Jr., Interview with José Bedia, LatinArt.com, October 7, 2001, www.latinart.com/transcript.cfm?id=30.

5. "Exhibitions: Shirin Neshat (August 28–November 7, 2004)," Auckland Art Gallery website, www.aucklandartgallery.govt.nz/exhibitions/0408neshat.asp.

6. Philip Taaffe, "Philip Taaffe: Statement for *Confluence* (exhibition and catalogue)," Philip Taaffe website, www.philiptaaffe.info/Interviews_Statements/ConfluenceStatement.php.

### It's All There in Black and White

1. Hunter Drohojowska-Philp, "His Specialty: One-Liners," *Los Angeles Times*, August 22, 1999, 56, articles.latimes.com/1999/aug/22/entertainment/ca-2447.

### Memory

1. José Luis Barrio-Garay, "Intention, Object, and Signification in the Work of Tàpies," in *Antoni Tàpies: Thirty-three Years of His Work* (Buffalo, NY: Albright-Knox Art Gallery, 1977), 18.

2. Art21, "Objects and Ideas" (Interview with Josiah McElheny), *Art21* Season 3, 2005, www.pbs.org/art21/artists/mcelheny/clip1.html.

3. Art21, "Total Reflective Abstraction" (Interview with Josiah McElheny), *Art21* Season 3, 2005, www.pbs.org/art21/artists/mcelheny/clip2.html.

### Into the Night

1. Artist's statement in *Vija Celmins: New Paintings, Objects, and Prints* (New York: McKee Gallery, 2010).

### The Museum as Canvas

1. Jim Lambie, Albright-Knox Art Gallery audio tour, *Extreme Abstraction*, 2005.

2. Martin Wisniowski, "Cory Arcangel on Tinkering and Doing Stuff," *Digital Tools*, August 2007, digitaltools.node3000.com/interview/103-cory-arcangel-on-tinkering-and-doing-stuff.

3. Erik Bryan, "Interview: Cory Arcangel," *The Morning News*, December 16, 2009, talks.themorningnews.org/2009/12/cory-arcangel.php.

4. Sol LeWitt, "Paragraphs on Conceptual Art," *Artforum* 5, No. 10 (June 1967): 79–83.

5. "Ingrid Calame: Step on a Crack . . . ," Albright-Knox Art Gallery website, www.albrightknox.org/education/artist-in-residence-program/ingrid-clame/.

6. Adrian Schiess, Albright-Knox Art Gallery audio tour, *Extreme Abstraction*, 2005.

### Into the Future

1. "Kiki Smith," *Journal of Contemporary Art*, www.jca-online.com/ksmith.html.

# INDEX OF ARTISTS AND ILLUSTRATIONS

# PHOTOGRAPH CREDITS